How To Paint With
WATERCOLORS
ALWYN CRAWSHAW

W9-BRS-709

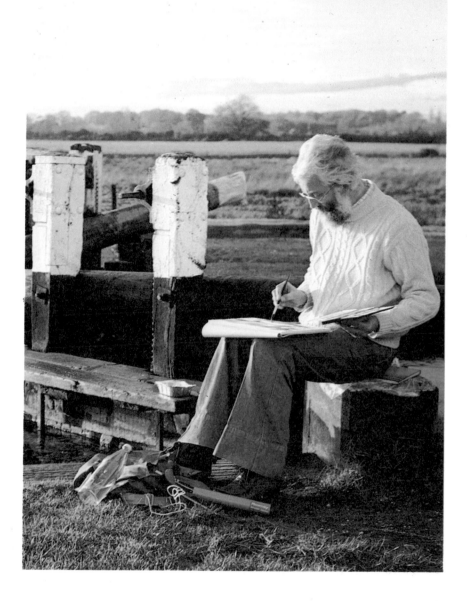

HPBooks

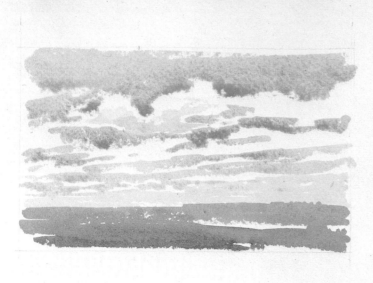

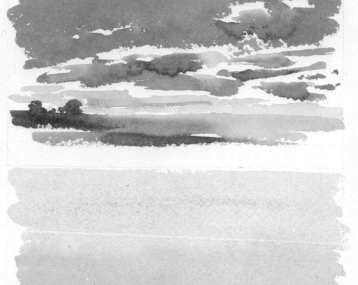

Published in the United States by
HPBooks
P.O. Box 5367
Tucson, AZ 85703
602/888-2150

Publishers: Bill and Helen Fisher
Executive Editor: Rick Bailey
Editorial Director: Randy Summerlin
Art Director: Don Burton

©1979 Alwyn Crawshaw
©1982 Fisher Publishing, Inc.
Printed in U.S.A.

First Published 1979 by
Collins Publishers, Glasgow and London

ISBN 0-89586-157-7
Library of Congress Catalog Card Number: 81-85412

Notice: The information in this book is true and
complete to the best of our knowledge. All
recommendations are made without guarantees on the
part of the author or HPBooks. The author and HPBooks
disclaim all liability incurred in connection with the use
of this information.

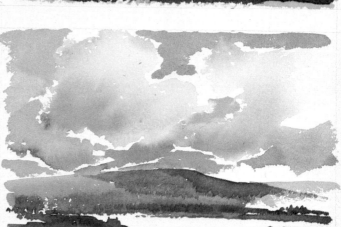

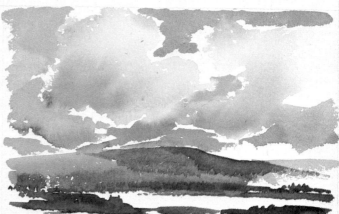

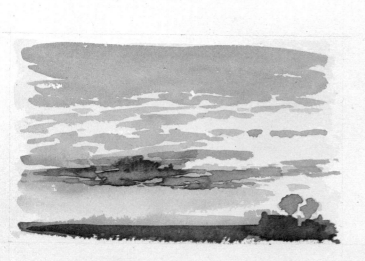

CONTENTS

Portrait Of An Artist— Alwyn Crawshaw

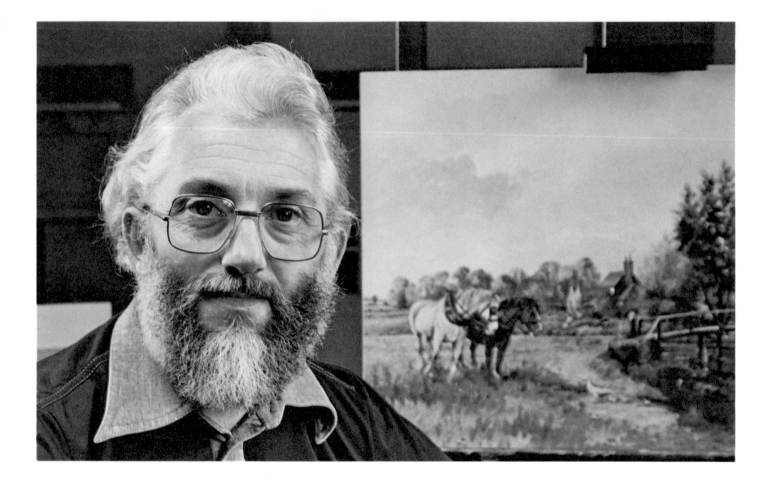

Alwyn Crawshaw was born in 1934 at Mirfield, Yorkshire, England. He now lives in Surrey. During his earlier years, he studied watercolor and oil painting. More recently he has studied acrylic painting.

Crawshaw is now a successful painter, author and lecturer. His work has brought him recognition as one of the leading painters in his field.

Crawshaw paints *realistic subjects.* These include many English landscape scenes.

His work has received critical acclaim. In most of Crawshaw's landscapes there is a distinctive trademark—usually elm trees or working horses.

Crawshaw's work became popular after his painting, *Wet and Windy,* was included in the top 10 prints chosen by members of the Fine Art Trade

Guild in England in 1975. Fine art prints of this painting are still in demand throughout the world.

Another now-famous painting was completed during Queen Elizabeth's Jubilee Year in 1977. Crawshaw wanted to record an aspect of Britain's heritage. He completed *The Silver Jubilee Fleet Review 1977* after long research and many hours working on location.

Crawshaw has been a frequent guest on Britain's radio talk shows. He demonstrates his techniques to members of many art societies throughout Britain.

His paintings are on exhibit throughout the world.

Crawshaw has exhibited in one-man shows at the art gallery of Harrods department store in London. Another one-man show was opened by the Duchess

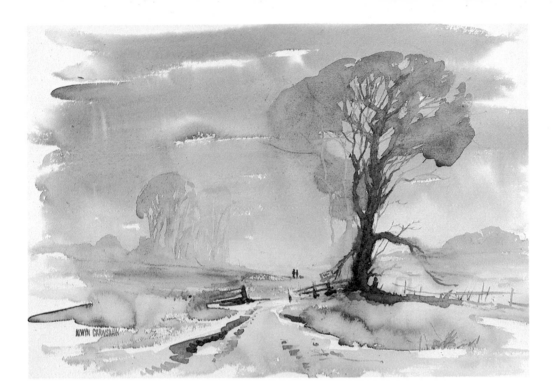

Between The Showers,
18x13-3/8". Private collection, London.

of Westminster, who now has a Crawshaw painting in her collection.

One-man exhibitions of his work draw an enthusiastic audience. There is an air of reality about his work, an atmosphere that many find appealing.

Crawshaw and his wife have three children—two teen-age daughters and a younger son. On weekends or holidays, a sketching day frequently turns into a family outing.

According to Crawshaw, there are two attributes necessary for artistic success: *dedication* and *a sense of humor.* The need for the first is self-evident. The second "helps you out of many a crisis."

Home To The Farm, 24x14". Author's collection.

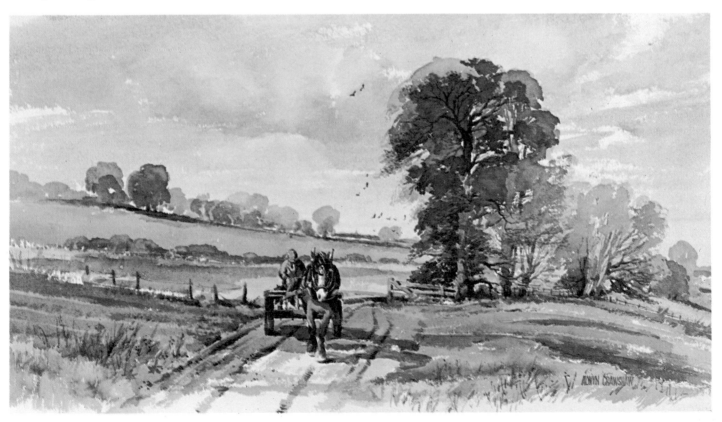

Why Paint?

Painting is one of man's earliest and most basic forms of expression. Stone Age men drew on cave walls. Their drawings were usually of wild animals and hunting scenes.

Primitive art may have been instructional—a means of showing children what certain animals looked like. They may have been a form of cave decoration. Perhaps they were just a pastime to release creative feelings.

Stone Age artists must have been creative and dedicated. There was no local art shop to help them with materials and no electricity to brighten dark days.

All this started more than 25,000 years ago. Painting is still with us today and has become sophisticated. It has survived thousands of years of changing civilizations, styles, ideas and techniques.

Artist's materials have undergone vast changes. The wide range of media and equipment now available—plus the variety of methods that are taught—can make painting frightening for the beginner. People can be put off by not knowing where or how to start.

I often hear people express a desire to paint. They usually say they have never tried and don't know where to begin.

Author Alwyn Crawshaw is shown here painting in the studio. He will guide you step by step as you experiment with the styles and techniques of watercolor painting.

How can a person say he can't paint when he has never tried?

Let me clear your mind about some of the *mysteries* of painting, from the beginner's point of view.

You may feel intimidated by the volume of art that has been created over the past thousands of years. There are hundreds of styles and techniques, from painting on ceilings to painting miniatures.

You may be confused by names such as *Prehistoric, Greek, Egyptian, Byzantine, Chinese, Gothic, Florentine, Impressionism, Surrealism, Abstractionism, Cubism* and so on. All these terms boggle the mind.

To unravel them all and understand the differences could take a lifetime.

Then where do you start? The simplest answer is to temporarily disregard all you have learned. Start from the beginning, like the Stone Age men.

Today, most people who want to paint have one thing in common—a *creative instinct.* Unfortunately, some people don't realize this until later in life, when something stirs within them or circumstances may lead them to painting.

For some, painting becomes a fascinating and relaxing hobby. For others, it becomes a way of expressing inner thoughts and communicating. For housebound people, painting can be therapeutic.

People can meet and make friends by joining art societies or by selling their art at local shows or in galleries.

I think painting is a creative way to express your feelings. You can forget all your immediate troubles and produce a work of art to share and enjoy with others.

You are taking your first big step by reading this book. This means you are curious about painting and want to learn about it.

You have selected a medium: *watercolor.* Now you are ready to learn about watercolors as a new technique.

I will take you through this book step by step, working simply at first. Then we will progress to a more advanced form of painting.

If you have some watercolors, the most difficult thing to do at the moment will be to continue reading. Your desire to try out the paint will be stimulated by looking through the book. Leave the paints alone for the moment. Note the color illustrations and different methods of working. Relax before you go on.

When you start the lessons and exercises, enjoy them. You may find some parts difficult. Don't become obsessed with the problem. Go to the next stage and then come back. Look at the problem with a fresh eye. That will make it easier to solve.

Watercolors— A Unique Medium

I am often asked why I paint in more than one medium. The reasons are varied. An artist sometimes uses a medium because he has been commissioned to do so. He may do it because he likes one medium more than another.

Each medium has its own characteristics and qualities. There is a restraint of size. Watercolor paper isn't made large enough for 30x60" paintings and neither is pastel paper. So the medium can determine the size of the painting.

Subject matter has to be considered. When I am looking for possible subjects, I see one scene as ideal for an acrylic painting. Another may be perfect as a watercolor.

What is *your* reason for choosing watercolor? Perhaps it's the obvious one—you like it! *You* have made the choice. Now we can work together from simple beginnings to more serious exercises.

Your earliest recollection of painting as a youngster may be associated with water-based paint. These include poster paints, powdered paints or watercolors. You may have the impression that it is *easy*.

To enjoy painting and get favorable results is relatively easy. But to get the desired results through deliberate *control* of watercolors requires *a lot* of practice and patience. The more you learn, the more you will enjoy using watercolors.

Watercolors are so called because the adhesive that binds the pigment powder to the paper is soluble in water. The paint is a finely ground mixture of *pigment, gum arabic*—the water-soluble gum of the acacia tree—and *glycerine* to keep the colors moist. It also contains *glucose* to make colors flow freely.

Here's how watercolor is applied: A brush is dipped in water. This is called *loading* the brush. The brush is applied to the paint on the palette. The paint becomes a colored, *transparent* liquid. This is then brushed on the white paper. The paper *shows through* and the paint has a *transparent luminosity* unequaled by any other medium. These watery strokes of watercolor pigment on paper are called *washes*.

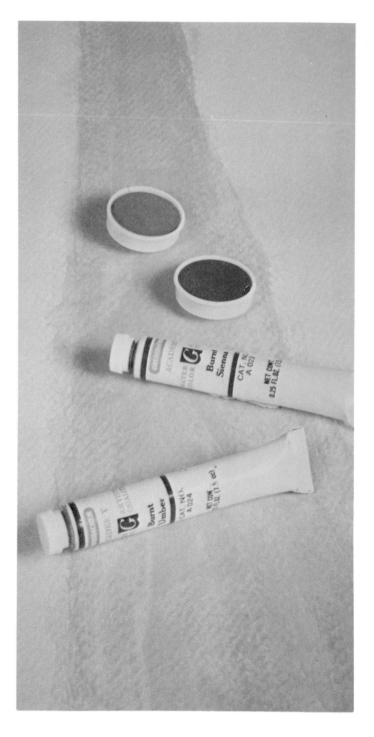

You can buy colors in half pans, whole pans or tubes, as in the photograph at left. I will explain more about this in the equipment section.

One great advantage of watercolor is that it requires no complicated equipment. Outdoor painting requires only the basic box of paints, brush, paper and water.

Watercolor dries within minutes of its application to paper. The water evaporates, leaving dry color on the surface.

This process can be seen when you're working. When the paint is shiny and wet on the paper, you can move it or add more color with the brush. As soon as the shine goes away, the paint is in an advanced drying stage. You must leave it alone and let it dry. Don't try to work more paint into it. You will get streaks and blotches. Paint dries quickly—especially if you are under a hot sun.

Watercolor painting does not favor faint hearts. If you think you are in that category, don't worry. You will gain confidence as you read and work through the book.

Have a strategy in mind before you start a painting. This will become second nature to you as you progress.

When I was in art school, I was taught to *look* and *observe.* Now I always look at the sky as if it could be a painting. I consider how it could be done, in which medium, with what brush, in which color and so on. I see things as *shapes, colors* and *techniques* of painting.

I see most things as watercolor paintings. This is because of the nature of the medium. You have limited time, you paint from light colors to dark and a bad mistake can't be overpainted. It involves observation and planning. You have to accept the fact that not every watercolor painting is a success—*especially not to you,* the artist. You may paint a beautiful picture, and everyone will like it. It may be worthy of exhibition. But there will be sections of that painting where the watercolor was not completely under your control.

This is an accepted characteristic of watercolor painting. Only the artist knows how he made the paint behave or misbehave. When you paint a *good* watercolor fully under your control, then you will have achieved something. It can elevate you into that special band of dedicated watercolorists.

At right is a color chart of watercolor hues that I use. They are set out in my palette order and will be referred to throughout this book. This chart is slightly affected by limitations of printing. It is intended only as a guide.

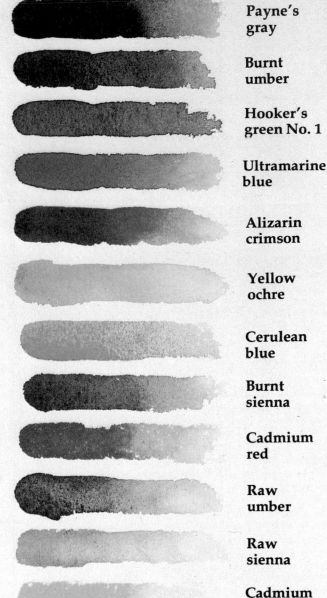

Payne's gray

Burnt umber

Hooker's green No. 1

Ultramarine blue

Alizarin crimson

Yellow ochre

Cerulean blue

Burnt sienna

Cadmium red

Raw umber

Raw sienna

Cadmium yellow pale

Additional watercolor hues available

Chinese white	Indigo
Chrome lemon	Monestial blue
Chrome orange	Permanent red
Chrome orange deep	Permanent sepia
Chrome yellow	Permanent yellow
Hooker's green No. 2	Purple lake
Indian red	Purple madder (alizarin)
Ivory-black	Rose dore (alizarin)
Lamp black	Alizarin scarlet
Light red	Scarlet lake
Naples yellow	Alizarin violet
Olive green	Aureolin
Permanent blue	Cobalt blue
Permanent magenta	Cobalt green
Permanent mauve	Cobalt violet
Prussian blue	Gamboge (hue)
Sap green	Lemon yellow
Terre-verte	Viridian
Vandyke brown	Cadmium orange
Venetian red	Cadmium yellow
Alizarin green	Cadmium yellow deep
Brown madder (alizarin)	Permanent rose
Brown pink	Carmine
Crimson lake	Scarlet vermilion
Indian yellow	

Equipment

Every experienced artist has favorite brushes, colors and other equipment. The choice must be left to you. Trial and error will help you settle on preferred supplies.

In the preceding chapter, I gave you a list of colors that I use. I suggest that you paint with these as you work through this book. I will refer to them to describe different color mixes.

You may prefer to omit some colors or add some once you have made progress.

To get best results, use the best materials you can afford. The two main distinctions between different watercolor paints are *cost* and *quality.*

The best-quality watercolor paints are called *artists' quality watercolors.* The next grade lower is called *student watercolors.*

You can buy watercolor paints in a watercolor box. Boxes come empty or ready-filled with colors, as in the photographs at right and on the opposite page. A small box is ideal to carry with you for impromptu sketching.

Some boxes carry *tubes* of liquid, pastelike paint. You squeeze the color onto the palette—the open lid of the box. Colors in tubes are ideal for quickly saturating a brush in strong color. Tube colors require less water.

I do not advise beginners to use tubes. It's more difficult to control the amount of paint on your brush.

You can buy many types of *palettes* for mixing colors. Some of these are shown in the photograph on page 13. Many materials are shown that you may require as you progress. A list of basic equipment on page 13 is accompanied by a tracing chart.

Brushes are the tools of the trade. The best-quality watercolor brushes are made from *kolinsky sable.* These handmade brushes are the most expensive on the market. They give you good control over your brushstrokes. The brushes will last a long time if properly cared for.

Fine-quality but less expensive watercolor brushes are made from *squirrel hair, ox hair* and *ring-cat hair.* Manmade fibers are also used in artists' brushes. Excellent *white nylon* brushes are available.

Brushes are the tools with which you express yourself on paper. It is only your use of the brush that reveals your skill. This applies to watercolor more than any other medium. *One brushstroke* can express a field, a lake, the side of a boat or many

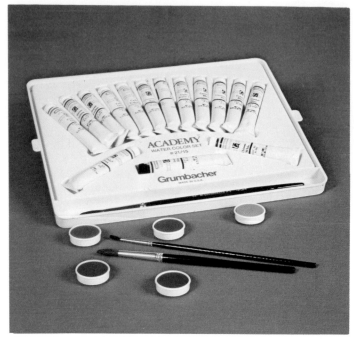

Watercolors can be purchased in basic sets consisting of tubes or pans, as shown above and on the opposite page.

other objects. You must know what to expect from brushes.

There are two basic types: a *round* brush and a *flat* brush. Brushes of many shapes made from different hairs are shown on the opposite page.

Handles of watercolor brushes are short. When the brush can be used for oil or acrylic painting, the handle may be longer. The flat ox hair brush is a good example. The round brush is an all-purpose one. Washes and thin lines can be painted with this shape. The flat brush is used mainly for putting washes over large areas or where broad brushstrokes are required. The width of these strokes is determined by the size of the flat brush. Round brushes are usually graded from No. 00 size to No. 12. Some manufacturers make larger sizes. This range of brush sizes is shown on the opposite page. Brushes are reproduced actual size.

Flat brushes and large brushes, such as the squirrel hair wash brush, have a name or size of their own.

Watercolor *paper* is an important piece of equipment. It is so important that I discuss paper in a separate section on pages 14 and 15.

You also need *pencils.* Start by getting an HB and 2B grade. Other grades up to 6B—the softest—are left to your own choice. A good-quality, *natural*

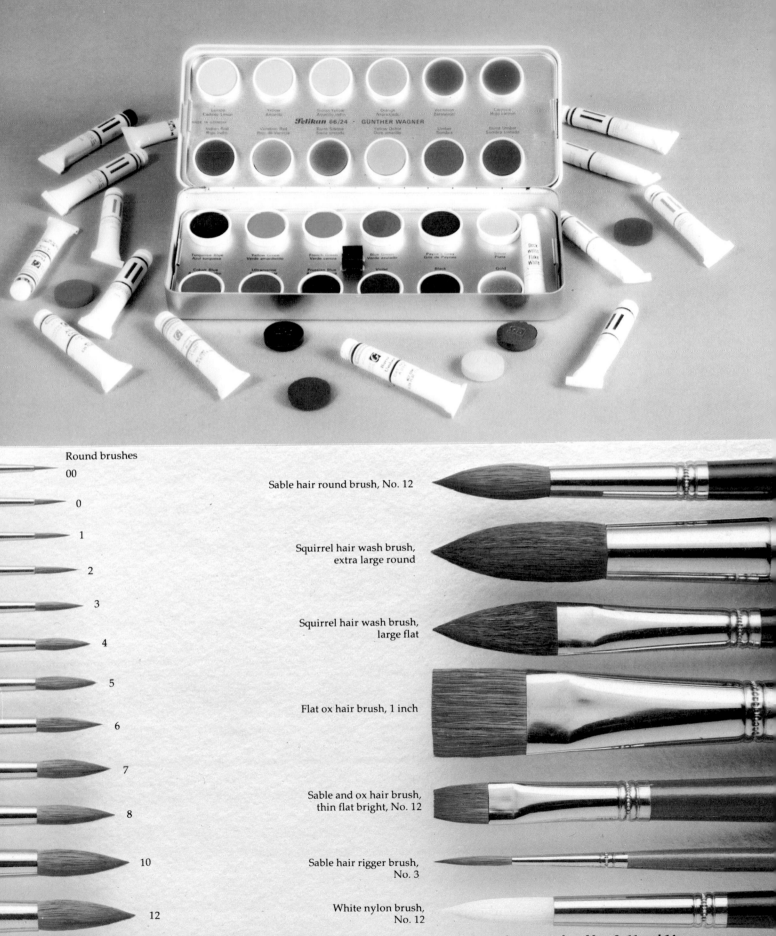

Round brushes

00

0

1

2

3

4

5

6

7

8

10

12

Sable hair round brush, No. 12

Squirrel hair wash brush,
extra large round

Squirrel hair wash brush,
large flat

Flat ox hair brush, 1 inch

Sable and ox hair brush,
thin flat bright, No. 12

Sable hair rigger brush,
No. 3

White nylon brush,
No. 12

All brushes are shown actual size. Some brush series have additional sizes to those shown, such as Nos. 9, 11 and 14.

sponge is helpful for wetting the paper or *sponging off* areas of color that you want to repaint.

You will also need *blotting paper,* such as tissue paper or paper towels, for absorbing wet color from the paper to lighten an area that is too dark. A *brush case* is necessary to avoid damaging brushes when you paint outside.

You need a *drawing board* to support your paper. You can make one from a smooth piece of plywood or you can buy one from an art shop.

A *container* to hold your painting water can be anything from a jam jar to a plastic cup. Make sure it is big enough to hold plenty of water. Keep changing the water so it is always clean.

A *kneaded eraser* is recommended. It can be used gently on delicate paper without causing too much damage to the surface. You will need a *dip pen* and *black India ink* when you use the pen-and-wash technique in exercises.

A watercolor should never be painted precisely to the edge of the paper. It is a good idea to have some *mat boards* for holding up to a finished watercolor. You will then be able to see where the painting will be masked when it is framed.

Cut mats of various sizes. When you have finished a painting, put a mat around it to evaluate your work. This will help you decide if your picture looks finished.

Your essential equipment is shown in the bottom photograph at right. You can start with only three brushes—a No. 10 round brush, a No. 6 round brush, and either a squirrel hair wash brush or a 1-inch, flat, ox hair brush. The wash brush is for covering extra-large areas with washes. The quality of brushes you get depends on the price you pay.

You need a paintbox to hold 12 colors in half pans, whole pans or tubes, HB and 2B pencils, kneaded eraser, drawing board, paper, sponge and water jar. I haven't included an easel because it is not an *essential* piece of watercolor equipment. When you work outside, your painting is usually small enough to manage on a drawing board or watercolor block—discussed on page 14—resting on your knees.

This short list represents what you need to paint with watercolors. The equipment, approach and execution are simple. Watercolor is fun, but you can achieve control over it only after considerable experience.

Back to the drawing board—or easel. You can work comfortably at a table. The top edge of your drawing board can be supported by a book or piece of wood 3 or 4 inches high. This allows your washes to run down correctly. If you want to work on an easel, choose one from the many types on the market.

Brushes in case

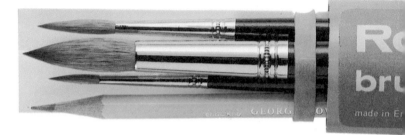

Beginner's basic equipment

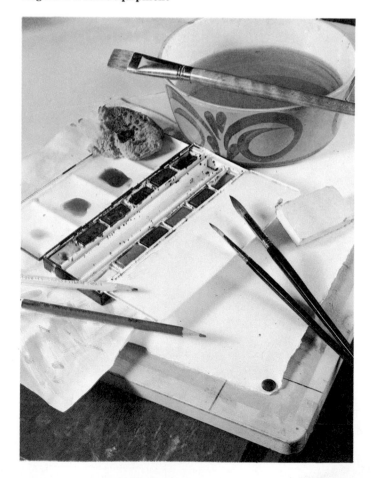

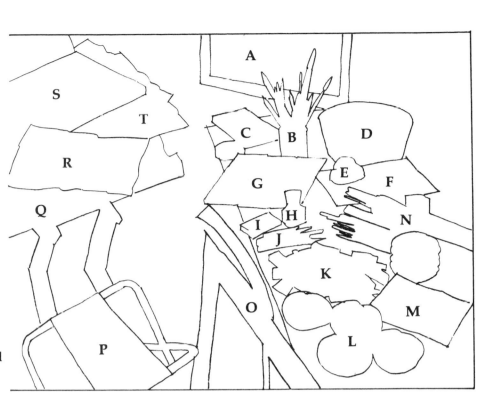

A	Stretched paper
B	Brushes and pencils
C	Mixing palette
D	Water container
E	Sponge
F	Watercolor box with tubes
G	Watercolor box with whole pans
H	Black ink
I	Kneaded eraser
J	Pencils and dip pens
K	Tubes, whole pans and half pans
L	Mixing palettes
M	Pocket-size watercolor box
N	Brushes in brush case
O	Mat boards
P	Outdoor stool
Q	Studio easel
R	Blotting paper
S	Block of watercolor paper
T	Various papers on drawing board

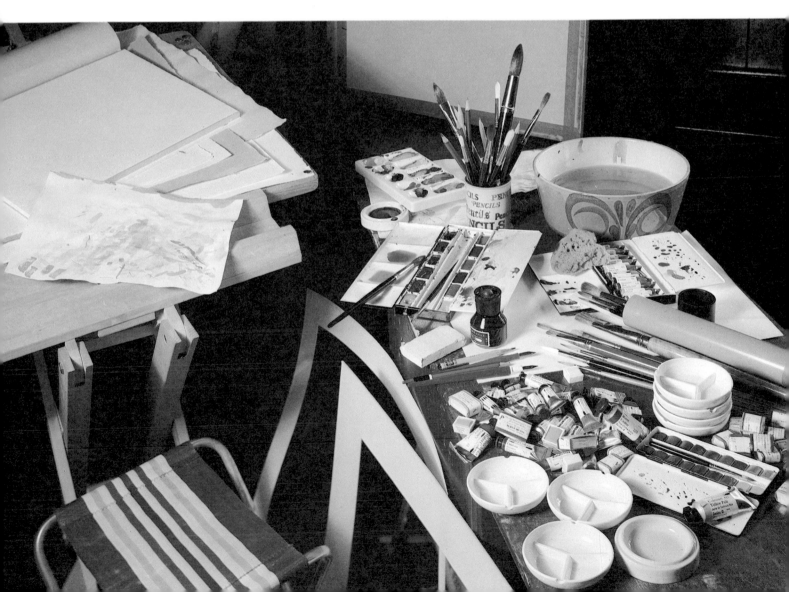

Paper

You can learn to paint with watercolor on almost *any* type of paper. You can work on *drawing* paper, on the inside of a *cardboard carton* or even on the back of a roll of *wallpaper*.

There will be problems if you are careless in your choice of paper. If the paper is too absorbent, the liquid will be sucked into the surface like ink on blotting paper. If the surface is non-absorbent, the paint will run out of control.

The answer is to use paper that is specially made for watercolor painting. The finest-quality papers are handmade by craftsmen whose skills have been handed down for centuries. Until the beginning of the 19th century, even the cheapest wrapping paper was made by hand. Then machinery took over much of the production.

Top-quality, handmade watercolor paper is expensive. But, compared to a ready-stretched oil canvas of comparable size, top-quality paper is *cheaper*.

Watercolor papers have a surface texture called *tooth*. It is this tooth that resists the brush and helps create the unique watercolor effect.

Watercolor papers also have the right amount of absorbency to hold liquid color under manageable control. There are many types of paper on the market, but they all have two things in common: They are all finished with one of three kinds of surface texture and are graded by weight, which indicates the thickness of the paper.

The surfaces are *rough*, *cold-pressed* and *hot-pressed*.

Paper with a rough surface has a pronounced tooth. It is usually used for large paintings in which bold, vigorous brushwork is required.

The cold-pressed surface has less tooth. This grade is popular with many artists. It is ideal for the beginner.

Hot-pressed paper is smooth, with very little tooth. Before you try this paper, you need to know how to control watercolors. If you use paint with a lot of water, it can be hard to control on hot-pressed paper.

One of the most popular watercolor paper sizes is the *Imperial sheet*—22x30". Handmade paper sizes can vary slightly.

Paper weight is designated by the weight of a ream—500 sheets. If a ream weighs 300 pounds—which is about the heaviest paper you can use—then a sheet of paper is called a *300-pound sheet*.

A good weight to work on is 140-pound paper. In the beginning, get used to two or three types of paper. Learn how paper reacts to paint and what you can and can't do.

When you first buy paper, pencil the name, size and weight in each corner for future reference. On the opposite page is a photograph of watercolor papers, reproduced in actual size. I have put some paint on each one to show the paper's surface.

Paper tends to buckle when you put watery paint on it. The thinner the paper, the more it will buckle. I explain below how to overcome this problem by *stretching* the paper. Heavy, thick papers do *not* have to be stretched.

Paper can be bought in sheets glued together on the edges of all four sides to prevent buckling. These are called *watercolor blocks*. They come in various sizes and are excellent for outdoor use. When the painting is finished, you tear off the sheet and work on the next one.

You must first practice and gain confidence in handling colors on inexpensive paper. After that, buy the best paper you can afford. Stick to that one until you know its characteristics well.

The better you know your brushes, paints *and* paper, the more you will enjoy painting.

HOW TO STRETCH PAPER

Cut a sheet of paper the size you need but *smaller* than your drawing board. Submerge it in a sink full of water or hold it under a running tap. *Completely soak* both sides.

Hold the sheet up by one end. Let the surface water drain off. Then lay it on a *wooden* drawing board.

Use a roll of brown, gummed tape to stick the four sides down. Allow the tape to overlap the paper's edge onto the board. An alternate method is to pin, tack or staple the paper to the board.

Leave the paper to dry overnight. In the morning, it will be tight and flat. It will stay flat while you work.

The finished result is shown in the photograph at the top of this page. It is a delight to paint on.

Arches 90-lb. hot-pressed

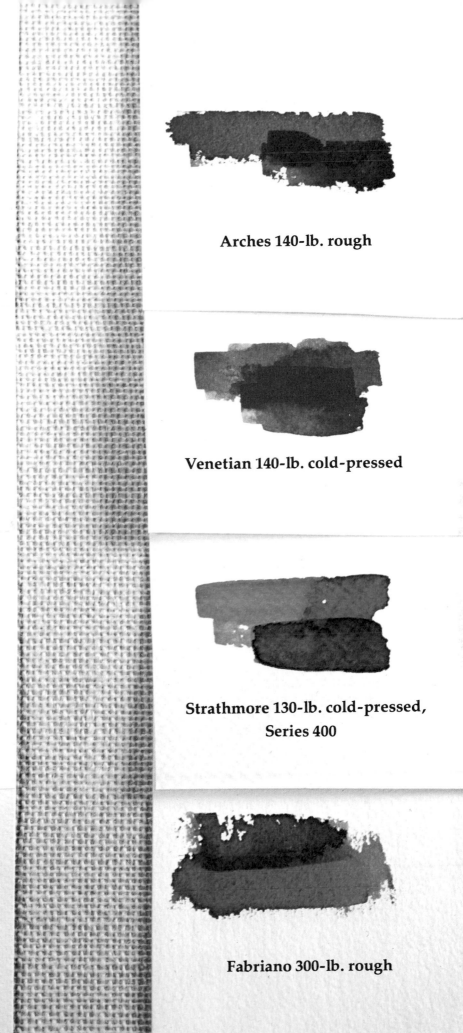

Arches 140-lb. rough

Fabriano 90-lb. hot-pressed

Venetian 140-lb. cold-pressed

Strathmore 140-lb. cold-pressed

**Strathmore 130-lb. cold-pressed,
Series 400**

Morilla 140-lb. cold-pressed

Fabriano 300-lb. rough

Start Painting

Experimenting with Paint

At last, you can start painting. Many people who have not painted before find this the most difficult task—to actually put some paint on paper.

We are all self-conscious when doing things we have never tried before. But don't be shy or reluctant when it comes time to paint. You have to begin somewhere.

It's human nature for us to strive to do better. If we try to run before we can walk, then problems will arise. So, let's start at the beginning and take things in a steady, progressive order.

Colors will be the first step. You may find hundreds of colors overwhelming. But the choice can be simplified.

There are only three basic colors: *red, yellow* and *blue*. These are called *primary colors*. They are illustrated on the opposite page.

All other colors and shades of color are formed by a combination of these three.

In painting, there are different red, yellow and blue pigments that we can use to help re-create Nature's colors. Look at the illustration. I have chosen two reds, two yellows and two blues to illustrate primary colors. These colors—plus another six—are the ones I use for all my watercolor painting.

Before you start mixing colors, get a piece of watercolor paper and experiment with paint. See what it feels like, try different brushes, add more water, use less water and discover what happens. You will end up with a strange-looking piece of colored paper. What you have done is experience the *feel* of watercolor paint. You will learn that if you add more water, you make the color *lighter*. This is the correct method for making watercolors lighter. You do *not* add white paint.

The paint, brushes and paper aren't strangers to you anymore. You have made a beginning. You will feel more confident in tackling the next section. Good luck.

Mixing Colors

As we progress through the exercises, practice mixing different colors.

Look at the illustration on the opposite page. I have taken primary colors and mixed them.

In the second row, cadmium yellow pale mixed with ultramarine blue makes green. In the third row, cadmium yellow pale mixed with cadmium red makes orange. To make the orange look more yellow, add more yellow than red. To make it more red, add more red than yellow.

Add more water to make the orange lighter.

Notice that my colors do not include black. Some artists use black and others don't. I do not.

I don't use ready-made black because I believe it is a "dead" color—too flat. I mix my blacks from the primary colors.

Practice mixing different colors on white paper. Mix the colors on your palette with a brush. Then make strokes on your paper. Don't worry about shapes at this stage. It's the colors you're trying for.

Experiment and practice. Look around you. Pick a color and try to match it by mixing your watercolor paint.

When there are only three basic colors, it is the *amount* of each color that is important. You can easily mix a green, as shown on the opposite page. But if it is to be a yellowish green, you have to experiment on your palette. Mix and work in more yellow until you produce the color you want.

This lesson of mixing colors is one that you must practice and improve all during your artistic life. I am still practicing.

Cadmium red Cadmium yellow pale Cerulean blue

Alizarin crimson Yellow ochre Ultramarine blue

Cadmium yellow pale **+** Ultramarine blue **=** Green

Cadmium yellow pale **+** Cadmium red **=** Orange

Cadmium yellow pale **+** Cadmium red **+** Ultramarine blue **=** Black

Doodle with your colors and see what happens

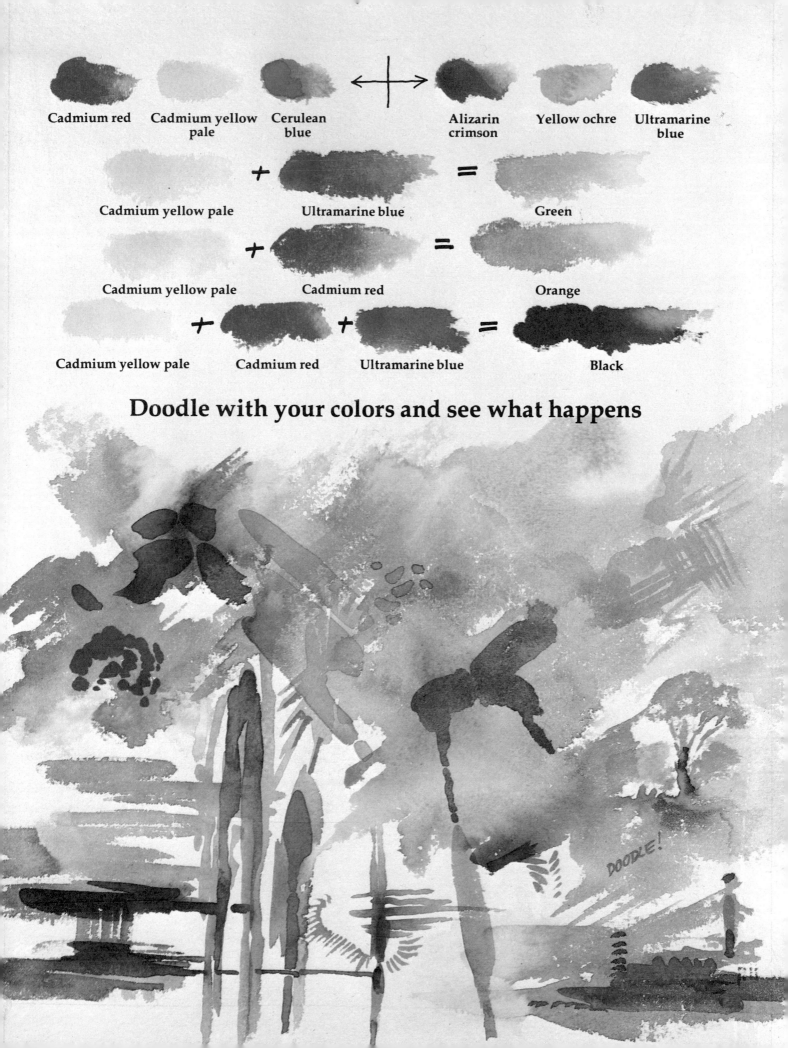

DOODLE!

Brush Control

Now you must learn to control the paintbrush. It is not as hard as you may think.

A lot of control is required when painting edges of areas that have to be filled in with paint. An example is the outline of a pair of scissors, as shown at top right.

Take a pair of scissors or anything handy that has round shapes. Trace it with an HB pencil. You can do this on plain white paper or watercolor paper.

Use your round sable brush with plenty of watery paint. When you fill in the curved shapes, start at the top and work down the left side to the bottom, as shown. Let the bristles *follow* the brush. Pull the brush down. Try to do this in two or three movements.

When you paint the right side of the handle, your brush will cover some of the pencil lines. This may seem awkward. The more you use your brush in this manner, the more natural it will feel. Practice!

Now, let's go on to straight lines. This time, draw a rectangle, such as the burnt umber box at right. Try this freehand without tracing.

Here is an *important rule:* When you draw straight lines—unless they are short—always *move your wrist and arm,* not your fingers.

Try this with a pencil. First, draw a straight line downward, moving only your fingers. You can draw only a few fractions of an inch before your fingers make the line bend.

Now do the same exercise with your fingers firm, moving only your hand. Bend your arm at the elbow. The result will be a long, straight line.

Paint the box edges with the round sable brush. Use this same brush for filling in the rectangle with paint.

Draw two more rectangles and paint around both. Leave both rectangles white. Paint another box inside the bottom box, without drawing it first. Change the color as you paint, working from the top box to the bottom one. This exercise will keep you busy!

Now, create some other shapes and fill them in. Mix your own colors. Choose any color, perhaps the color of your carpet or a cushion. Try to mix a color like it to use for painting in the shapes. You are practicing all you have learned so far in one exercise. Do this often. Enjoy it and keep practicing.

Alizarin crimson and ultramarine blue

Burnt umber

From alizarin crimson to cadmium yellow pale

Perspective Drawing

The ability to draw must come before painting. Take time to practice simple *perspective drawing*.

If you believe you can't draw, don't let this exercise worry you. Some artists can paint a picture but would have difficulty doing it as a *drawing*. Colors, values and shapes of masses are what make a painting.

For centuries, artists have invented and used drawing aids. Now there is a simple, effective aid to drawing on the market called a *Perspectograph*. It determines the perspective lines for you. But it is not too difficult to learn perspective without aids.

When you look out to sea, the horizon will always be at your *eye level*. This is true even if you climb a cliff or lie flat on the sand.

There is no actual horizon if you are in a room. But you still have an eye level. It is referred to as the *horizon line*. To find this line, hold your pencil horizontally at arm's length in front of your eyes. Your eye level and horizon line is where the pencil appears to cross the opposite wall.

If two *parallel* lines were marked on the ground and extended to the horizon, they would appear to come together. Their meeting point is called the *vanishing point*. This is why railroad tracks *appear* to get closer together and finally meet in the distance. They have converged at the vanishing point.

Look at the rectangular boxes at right. I drew a line above box A to represent the eye level.

Near the right end of the eye level, I marked the vanishing point. I drew a line with a ruler from each of the four corners of the box, all converging at the vanishing point. This gave me the two sides, the bottom and top of the box. To create the other end of the box, I drew a rectangle parallel with the front of the box within the vanishing point guidelines.

The effect is that of a *transparent* box drawn in perspective. The view is from above the box because the eye level is high.

In box B, I have shaded the rectangles with pencil to show the light direction.

Boxes C, D and E show the same box, the first one painted with a wash of Hooker's green. Box D was painted with a second wash over two sides when the first wash was dry. Box E was painted with an additional wash on the darkest side. This made the box appear solid. Box F shows the same drawing painted to represent a hollow box.

This is a simple exercise. But it is one of the most important exercises you will ever do. You are creating the *illusion of depth, dimension* and *perspective*. The final product appears to be a three-dimensional box.

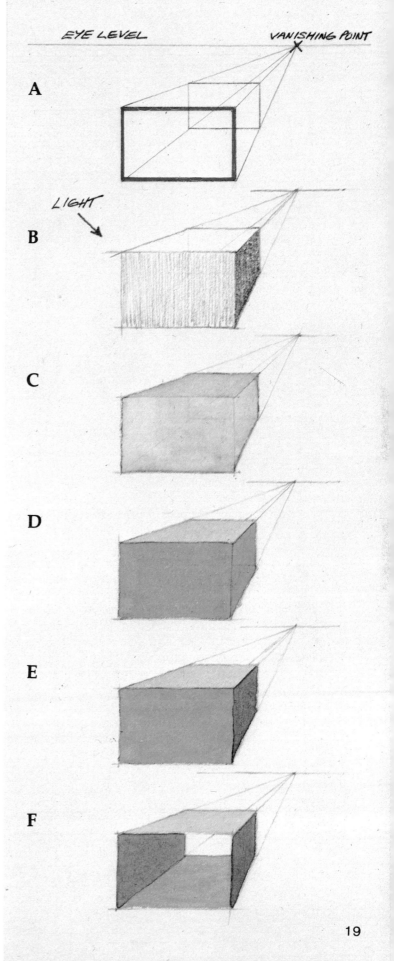

Basic Watercolor Techniques

Notice in box C on page 19 that the box looks *flat*. This is because there is no *light* or *shade*—light against dark. It is light against dark that enables us to see objects and understand their form.

We refer to the relative *lightness* or *darkness* of a color by the term *value*. We often refer to light values, middle values or dark values.

We could have painted the box *red* on a *red* background without adding light or shade. If we had done so, we would not be able to see it. If light and shade were added, it could then be seen.

You must always be aware of light against dark—or value—whenever you paint. When you paint a still life or a landscape, it helps you see shapes and masses if you squint your eyes. Lights and darks will be exaggerated. Middle values tend to disappear. Squinting helps you see simple, contrasting shapes.

When watercolor is wet, it appears dark and rich. But when it is dry, it is slightly lighter.

For now, don't worry about precise values. Don't get upset if you believe a painting has gone wrong or out of control. It happens to the best artists.

Remember this: *You can learn a lot from your mistakes.*

When painting, it is helpful if you keep your colors in the same position in your paintbox. Use the box the same way each time. You have enough to think about without wondering where your colors are.

The position of colors in my box is shown on page 12. I use a box with deep wash pans in the lid. I was taught in art school to work this way and have done so ever since.

FLAT WASH

Now we can study the most basic technique of watercolor painting—*the flat wash.*

I have used *arrows* in all instructive illustrations to help you understand the movement of the brush. The *solid-black* arrow shows the direction of the brushstroke. The *outline* arrow shows the direction in which the wash is painted over the paper.

In the photograph below, the brushstroke is moving horizontally, from left to right. The wash is being painted down the paper from top to bottom after completion of each horizontal stroke.

You need plenty of watery paint on your palette for a flat wash. Load your largest brush. Start at the top left corner of the paper. Take the brush along in a definite movement to the right. Don't rush.

When you get to the end, bring the brush back. Run it slightly into the first wet stroke and make

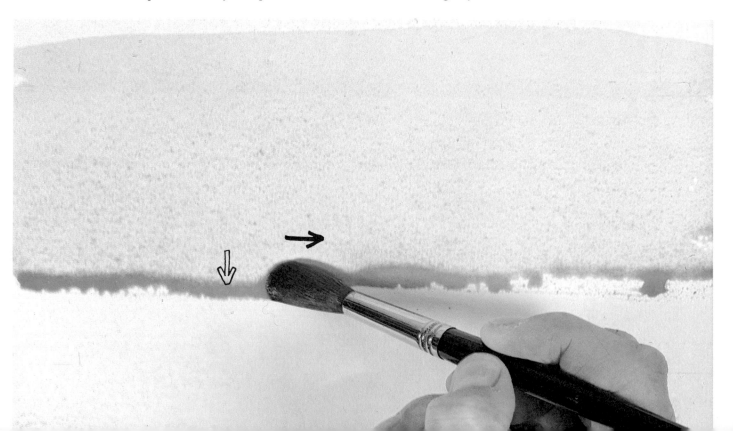

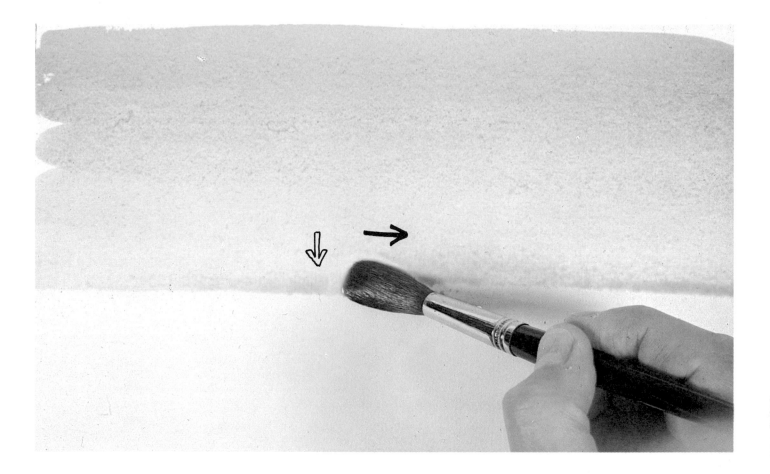

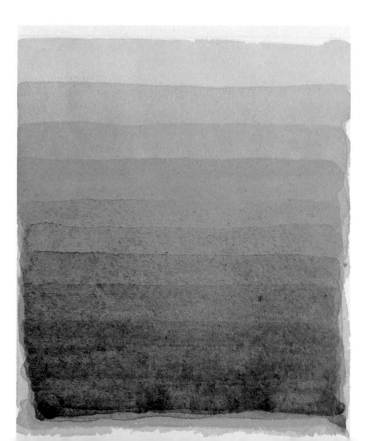

another brushstroke like the first. Add more paint to your brush when you need it.

Remember that the color was mixed before you started painting. You have added no more water. Be careful to make the color value of the wash the same all the way down.

Let this wash dry, then paint another one over it. Use the same color but start about 1/2 inch from the top of the original wash.

Repeat this process at least six times. You will begin to get the knack of painting a wash. Practice applying transparent color many times. The more washes you apply, the darker the color becomes. This process is illustrated at left. This light-to-dark image is called a *value scale*.

GRADED WASH

A *graded wash* is produced the same way as a flat wash, with one exception. As you work down the paper, add more water to the color in your palette. This dilutes the paint and lightens the value of the color. The result is a progressively lighter wash from top to bottom, as shown above.

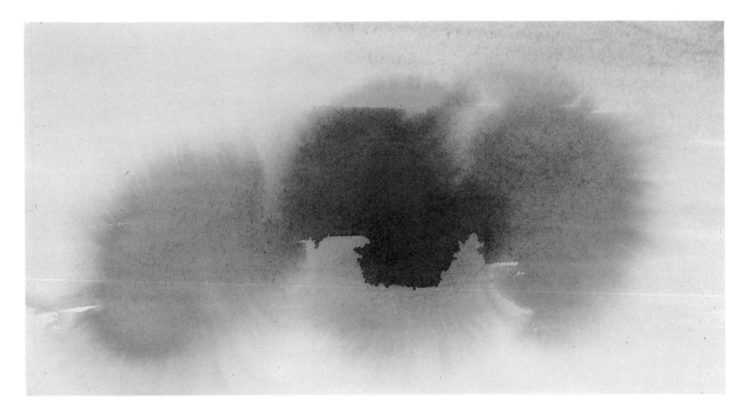

WET ON WET

The term *wet on wet* is common to many painting media. It means that wet paint is applied over existing wet paint. It is an interesting technique.

It is impossible to predict exactly what will happen when you put wet paint on top of a wet watercolor wash. Look at the washes pictured above and at right. You can create some unusual effects. Some of them are dramatic, others subtle.

The washes above were an experiment. I painted cerulean blue first, with plenty of water. Then I added a watery mix of Payne's gray and burnt umber in the middle.

When this was dry, I lightly sponged it with clean water. Then I painted the middle again with a mix of Payne's gray, ultramarine blue and burnt umber. This is strong color. I immediately added more water to the mix and put some on each side.

You will have more control over the paint if you wait until the first wash is drying. You will also achieve a slightly different effect.

Beautiful skies can be painted using the wet-on-wet method. Sponge the paper with clean water. Then paint sky colors. Let them run together.

Experiment with this technique and practice control. The overall effect is planned. It's the unpredictable movement of the paint that adds interest and beauty.

When it's dry, you may see an area that needs only a brushstroke to make it look better. This is

called an *accident* in watercolor painting.

If the brushstroke is applied correctly, this passage could be an attractive part of the painting.

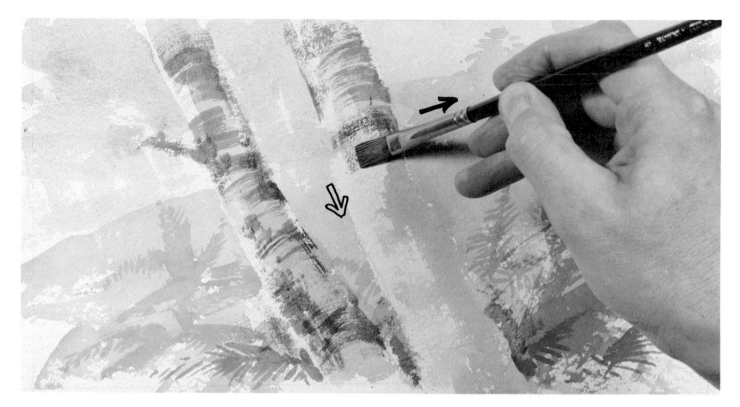

DRYBRUSH

Drybrush is another technique used in most types of painting. The term—actually a misnomer—means that a brush is only *damp* before being dipped into the paint. Or it can mean a *wet* brush is loaded with paint, then *dried to a damp consistency* on blotting paper. Then it is applied to watercolor paper.

The yellowish strokes at left are drybrush strokes.

This technique is used to achieve a *hit-and-miss* effect. If you try it on rough watercolor paper, it is relatively easy. But on smooth-surfaced paper, it takes practice.

You may have accidentally produced a drybrush effect when you were doodling or painting the boxes in earlier exercises. You were probably annoyed because you were running out of paint. But it was unintentional and uncontrolled.

The best way to learn the drybrush technique is to use *long* brushstrokes from left to right. Use only a little paint to produce strokes like those at left.

Your brush may start out wet, then run out of wet paint and finish the stroke with a drybrush effect. Try to control the amount of wet paint you load on your brush. Pull the brush several inches so the stroke is finished with drybrush.

When you can do this, you will have considerable control of your watercolor brushwork. In the illustration above, I used a No. 6 nylon brush for the drybrush strokes.

Different Ways To Paint

Watercolor is a versatile medium. Six artists could paint the same subject, using the same technique. But each painting would be *different*. Each artist would have his own style.

Look at my wet-on-wet watercolor at the bottom of the opposite page. It is painted in a different style than my pen-and-wash watercolor on page 27. An artist's style is altered by the technique he chooses.

To avoid confusion, in this chapter the word *style* refers to the artist's unique way of painting. The word *technique* refers to the method of using the paint, such as wet on wet, flat wash, pen and wash, and so on.

On the following pages are six paintings I did of the same subject. I used a different technique each time to demonstrate the versatility and beauty of watercolor.

I want you to compare several versions of the *same subject* so you can see the difference between each technique. Actual size of each painting is 13-1/2x9''. Weight and surface type of paper used is indicated below each painting.

Some subjects do not lend themselves to a particular technique. But the reverse is often true: Some subjects are ideal for one special technique.

You must choose your subject and technique carefully. A pencil-and-wash or pen-and-wash drawing can be done well only if you can draw well.

The basis for watercolor painting is still the *wash*—whether it's flat, graded or wet on wet. You can't practice painting washes too much.

You will be more relaxed at painting when you can handle washes well on small and large scales. Fewer mistakes will result. Keep practicing.

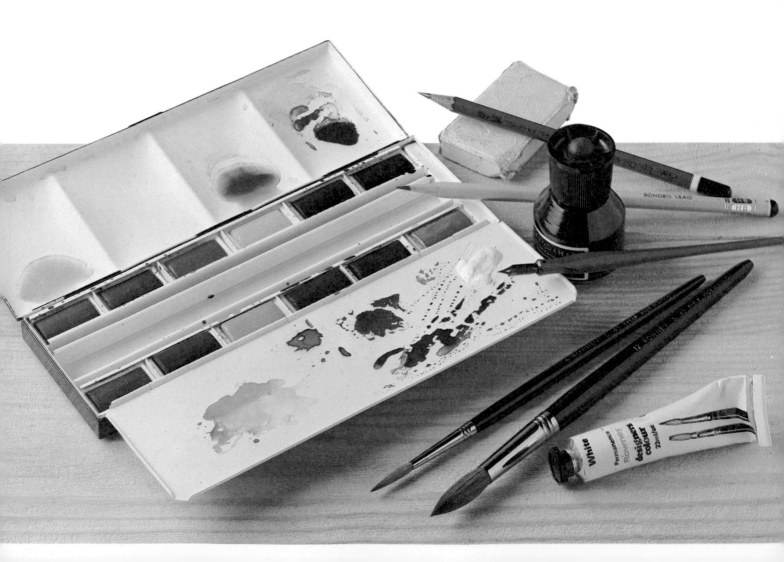

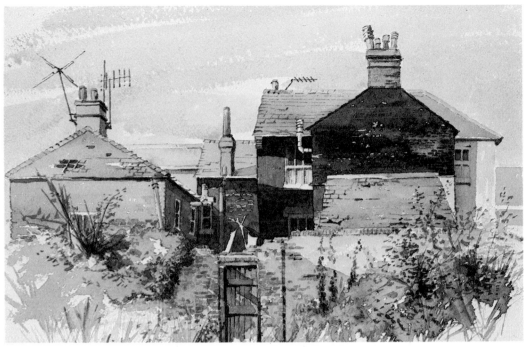

Flat wash and graded wash **300-lb. cold-pressed board**

FLAT WASH AND GRADED WASH

I regard the *flat wash* and *graded wash* as basic, traditional ways to use watercolor. First, think out your moves carefully. Then work up the effect with washes. Use the lightest colors first and work gradually to the darkest values.

It has always been thought that something old—especially a building—has character as a subject for the painter. I agree with this. That's why I chose buildings for the exercises in this chapter.

Television aerials are everywhere these days. Many artists either avoid old buildings with TV aerials showing or leave the aerials out of their paintings.

When I found the buildings for these exercises, I thought the TV aerials *added to their character and charm.*

WET-ON-WET TECHNIQUE

The wet-on-wet technique is an exciting way to use watercolor, but it can be difficult. The freedom and apparent ease of letting colors move around the paper excites artist and viewer alike. The finished result looks natural and unlabored. But you have to put in many hours of patient practice.

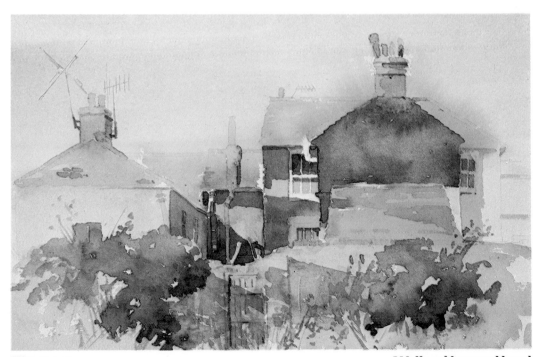

Wet on wet **300-lb. cold-pressed board**

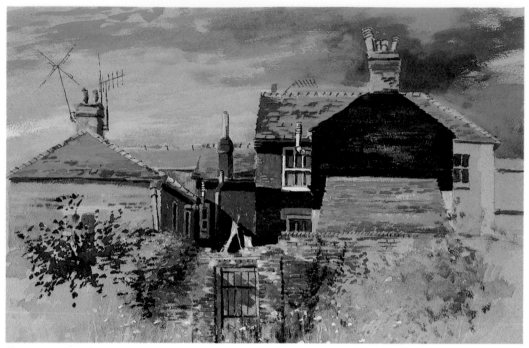

Opaque watercolor **72-lb. cold-pressed paper**

OPAQUE WATERCOLOR

You can strengthen colors by using the *opaque watercolor* technique. This means adding opaque white paint to take away the transparency of the color.

White is used instead of water in this technique to make colors lighter.

I made the sky dark for a dramatic effect. I used pure white where the sun lights the window frame.

When painting a transparent watercolor, you may find you have lost the quality desired. Try using white with your colors and convert it into an opaque watercolor painting.

In this technique, light colors can be painted over dark ones. This is the reverse of other watercolor techniques.

OPEN WASH

The painting below looks flat when compared to the others. But it demonstrates a crisp, clean watercolor technique.

I call the technique *open wash* because white paper is left *between* each wash. Open wash has charm and a valuable application. When you paint outside, it is often impractical to wait for each wash to dry before applying adjacent ones. You can continue without stopping if you use this method.

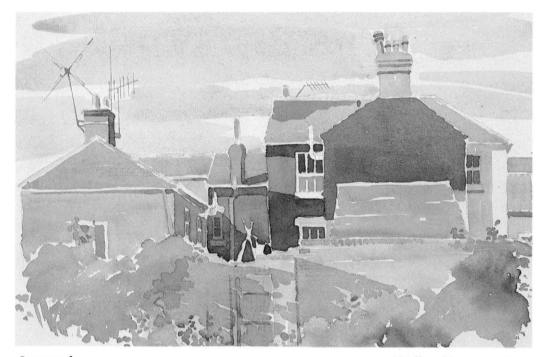

Open wash **281-lb. cold-pressed paper**

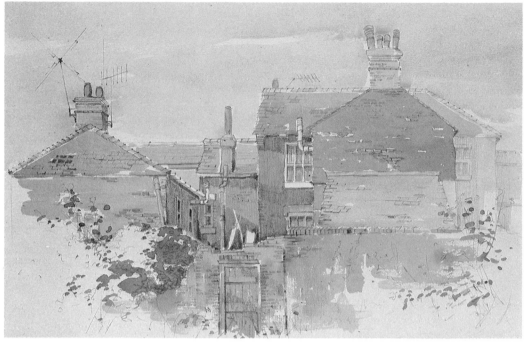

Pencil and wash **72-lb. cold-pressed paper**

PENCIL AND WASH

Pencil and wash is one of the most delicate ways to use watercolor. It can be sensitive and detailed.

I did the pencil drawing above as though it were *only* a drawing. All the shading was done with a pencil.

Flat washes of color were applied after the drawing was completed. This *fixes* the pencil lines and prevents smudging.

PEN AND WASH

Pen and wash is used by many watercolor artists. The addition of pen lines gives a sparkle to the painting.

I painted the picture below first, then added the pen work. But you can work the other way around—pen drawing first—if you find it suits you better.

The use of pen and ink is another method of *saving* a doomed watercolor, the same as with opaque watercolor. Next time you want to put more sparkle into a painting, try using a pen. You may transform a mediocre painting into a good one.

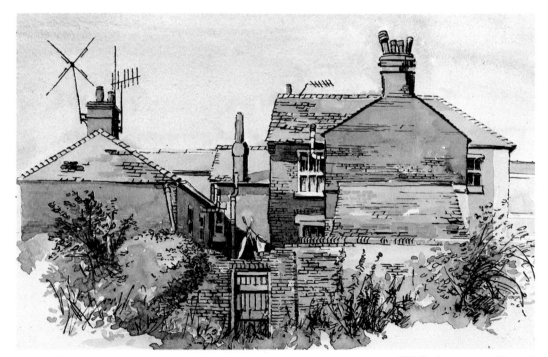

Pen and wash **300-lb. hot-pressed board**

27

Exercises

You will no doubt have some problems with paint. You may lose control of a painting or find that paint has broken away from the main wash. It may run down the paper onto the table or floor.

This is good experience when it happens. You can use this knowledge to improve your painting.

You may be using heavy, white writing paper or thin watercolor paper. If you have not tried *stretching* paper, now is the time to do so. It makes a great difference. Refer to instructions on page 14.

You must always have *clean* water in your container before starting a watercolor painting. Remember, paint colors the water. If the water is dirty, you will not get a true, clear color.

I sometimes speed up the drying time of a wash by using a hair dryer. This helps avoid breaking my rhythm by losing time while painting in the studio.

I have chosen a potato for the first exercise. The drawing is not too difficult. If you put a bump in the wrong place, it will not look wrong.

The color isn't bright or exciting, but it can be easily matched. Potato color is varied. If you don't match it exactly, your painting will still look correct.

You may have gotten the idea that if an object isn't represented correctly, it doesn't matter. This is not always true. The object must be painted realistically enough to convey the image or impression you want.

I want to make sure that your first painting of an object looks correct. This will boost your confidence and improve your work. I chose a potato because it has no specific shape or color.

First, draw the potato with an HB pencil. Use your large, round brush to paint the green background wash. When this is dry, paint the potato. Add more color on the shadow side as you paint down.

Before this paint is dry, use the same brush and darker color to create the dark blemishes. These marks will run a little and the edges will be soft. This is because the paint is still slightly wet.

Dry out your brush and wipe out some *highlights* while the paint on the potato is still wet. These are only subtle effects, but they help to give the object *form*.

Finally, put in the shadow. Don't be fussy with the detail. If it doesn't work the first time, keep trying. Before long, you should be able to paint a potato like the one at the right.

Try some more vegetables. They are good subjects for practice exercises.

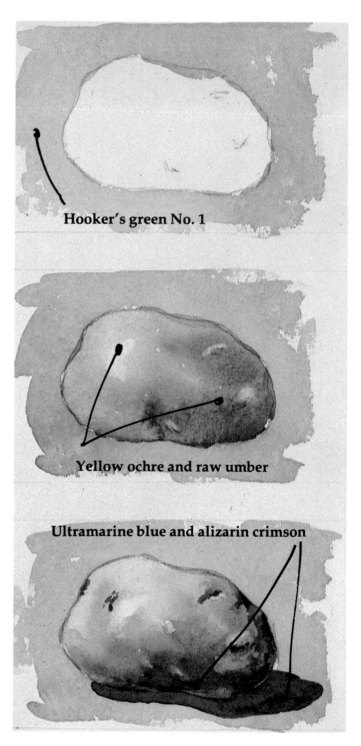

Hooker's green No. 1

Yellow ochre and raw umber

Ultramarine blue and alizarin crimson

SIMPLIFYING COMPLICATED SUBJECTS

Below is a complicated pencil sketch I made of a harbor. I put a lot of drawing time into this. I could have sketched only the key positions if I just wanted to paint it. These positions would include the horizon, the long wooden wharf and a couple of the main boats. The brush could do the rest.

In the bottom painting, I used a rough surface paper and a lot of drybrush. I also used a knife blade to scratch out the middle-distance highlights on the water. This illustrates the difference between a complex rendering and a simplified painting.

Complicated sketch

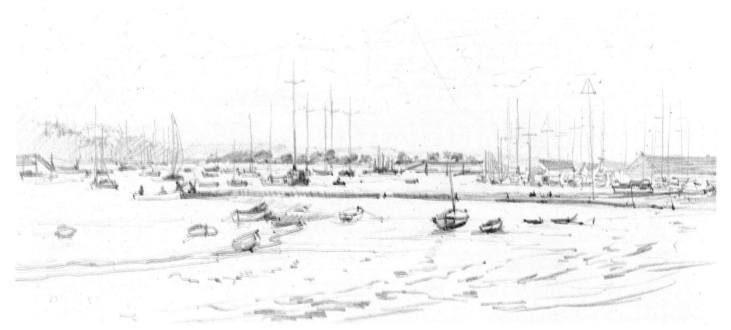

Simplified painting

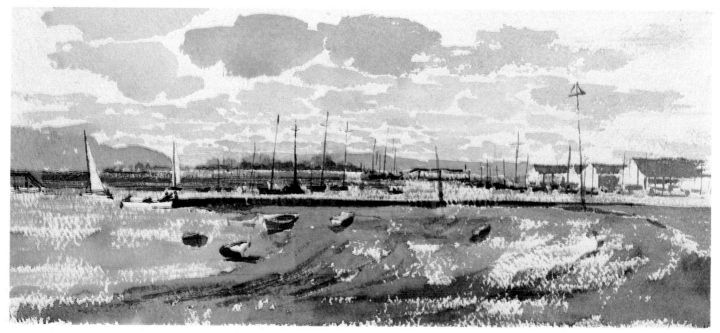

Painting a banana

Use these colors: Cadmium yellow pale
Burnt umber
Alizarin crimson
Ultramarine blue

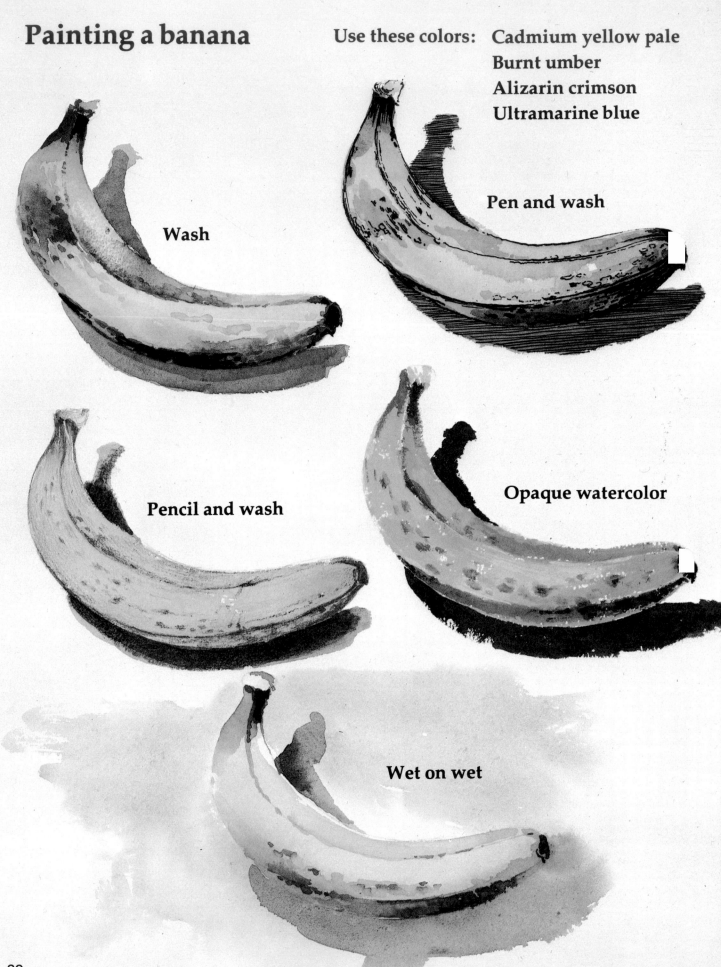

Wash

Pen and wash

Pencil and wash

Opaque watercolor

Wet on wet

BANANA EXERCISE

Try a *simple approach* using five of the techniques I described earlier. First, draw five bananas on the same sheet of paper with your HB pencil.

Now, paint the banana shapes. Use the same colors for all five. Paint the first one with a large, round brush and the colors shown at left.

Let the brushstrokes follow the shape of the banana. When the paint is almost dry, put on a darker wash and add some darker marks on top. Then paint a dark shadow wash to contrast with the banana—light against dark. Put in dark accents with your No. 6 brush to add detail.

Paint the pen-and-wash banana the same way. When the wash is dry, use a pen and black India ink to draw the banana. Experiment to find your natural style. Try drawing the banana with pen and ink first before putting colored washes over the ink.

The next banana is pencil and wash. Draw and shade the banana with HB and 2B pencils as if you were doing a pencil drawing. Pencil leads are graded up to 6B—the softest and so the darkest.

Then, paint the banana the same way as you did the first one. Paint over your pencil shading.

Now use the opaque watercolor technique. Use white to make the paint lighter and opaque. *Poster colors* or tubes of commercially mixed opaque watercolor—also called *gouache*—are usually used. You must *wash it off your palette* when you have finished.

Be careful if white paint is mixed with watercolor and applied to paper. If you put a wash over the top—or even a watery brush—it can run and ruin your work. Paint the banana with the same colors as before, but add white to them. Don't use a lot of water. Opaque paint does not flow easily. You have to work it more.

Finally, use the wet-on-wet technique. Use your sponge or large brush to wet the paper. While it is still wet, paint the banana with the same brush. The colors will run past the edges of your pencil drawing.

Then paint the darker side and add some dark blemishes. When this is almost dry, use the same brush to paint the background. Start at the left—above the banana. Follow its top shape in one brushstroke. Then work underneath it.

ROSE EXERCISE

Sketch a rose, stem and leaves with an HB pencil.

Use your No. 6 brush to put a wash of alizarin crimson and cadmium red on the flower. While this is still wet, wipe out some of the paint for highlights with a damp—not wet—brush.

Paint the stem and leaves. While the leaves are still wet, add some cadmium red with the point of the brush.

Paint the rose petals with darker color. When dry, scratch out some highlights.

Paint a wet background with the same brush. Be precise when painting up to the leaves. Let the brushstroke accentuate the shape. Add some shadow on the stem and leaves under the flower.

Cadmium red and alizarin crimson

Hooker's green No. 1, cadmium red and alizarin crimson

Burnt umber and Hooker's green No. 1

31

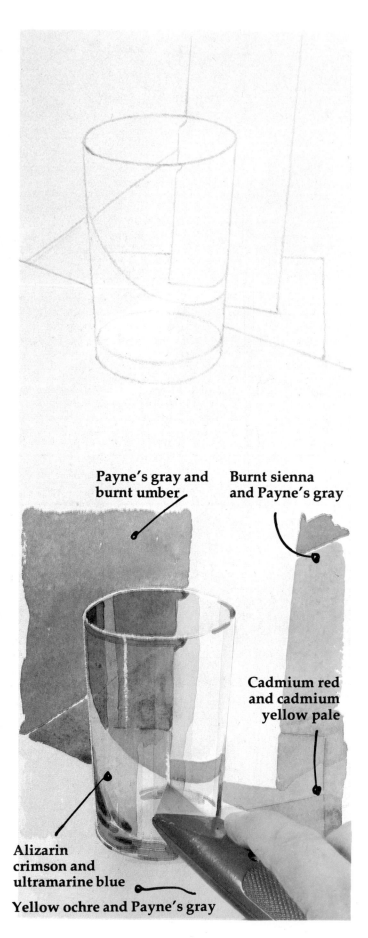

Payne's gray and burnt umber

Burnt sienna and Payne's gray

Cadmium red and cadmium yellow pale

Alizarin crimson and ultramarine blue

Yellow ochre and Payne's gray

DRINKING GLASS EXERCISE

I find that most students shy away from painting a glass. I am often asked how to make it look like *glass*. The answer is: *by observation*.

Look right through the glass and analyze the shapes behind it. Then draw the glass and simplify these shapes. Look at my drawing. Note that definite shapes are formed in the glass.

Use a large brush to paint the top-left, dark area first. Leave the rim of the glass white and paint down into the glass. Then paint the orange areas.

Next, use a pale wash for the white areas. Leave some unpainted white paper in the glass. Now, using downward strokes, put a dark wash down the left side of the glass. Leave some areas untouched.

When this is dry, go over the area again with darker color. Add a few dark accents with your small sable brush. Use a sharp blade to scratch out some highlights on the glass.

Always study the background shapes and colors as you look through glass. Paint these and your glass will look realistic.

SKY EXERCISE

I have said that the wash is the basis of all watercolor painting. If you have been practicing the basic techniques, you should now be able to handle a wash with confidence.

The previous two exercises—a glass and a rose—required a lot of thinking and careful brushwork. Now you can be a little more relaxed when painting skies.

If you get the overall shape of a cloud correct, it doesn't matter if you have an extra bump here and there. The sky is one of the best subjects on which to practice washes and large brushwork. You can produce an enjoyable painting even though it is an exercise.

Try this exercise for the sheer joy of painting. Enjoy the freedom that paint and subject matter allow.

My six paintings were all done on 300-pound cold-pressed paper. I recommend that you try all kinds of papers, surfaces, weights, colors and so on.

I painted them twice the size they are reproduced here. This is a handy size for practicing this exercise, because you have more control over the paint on a small area.

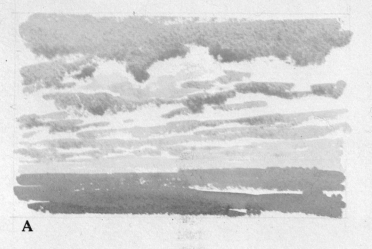

A

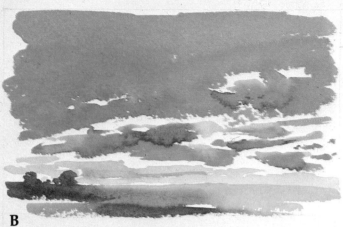

B

C

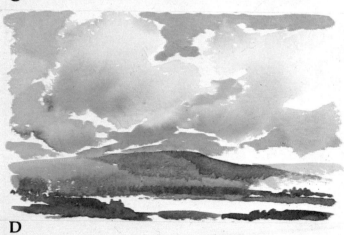

D

A Figure A portrays a clear, windy day. The clouds were moving rapidly across the sky. I used dry paper and a No. 10 brush. First, I painted a wash of cerulean blue and a little alizarin crimson for the sky. While it was wet, I added yellow ochre to the mix for the shadow of the clouds.

B In figure B, I applied a wash of Payne's gray, ultramarine blue and alizarin crimson to dry paper with a No. 10 brush. I left white areas for clouds. While the paint was wet, I painted the darker sides of the clouds. Then I added a touch of yellow ochre to the dark shadows.

C The evening sky in figure C has a normal graded wash worked from top to horizon and below the land. The paper was dry. I used cerulean blue, alizarin crimson and cadmium yellow pale for the wash. I painted with a No. 10 brush.

D The big, full clouds in figure D were painted first with a mixture of yellow ochre, alizarin crimson and ultramarine blue. Before they dried, ultramarine blue mixed with alizarin crimson was painted between them, leaving white edges. This produced a silver lining to help unify the clouds. Notice the small silhouette of a cottage near the bottom left and the white lake at the foot of the hills. This gives dimension to the clouds.

E A wet, drizzly day is pictured in figure E. The paper was soaked with a sponge, except at the bottom right corner. A mix of ultramarine blue, alizarin crimson, Payne's gray and yellow ochre was worked on the wet paper. You can see the result. Where the paper was dry at the bottom right, I let the brush form the cottage. Again, this was done to give atmosphere and dimension.

F For the evening sky in figure F, I applied a wash of alizarin crimson and cadmium yellow pale over the paper. When the wash was dry, I painted the clouds with a No. 6 brush. Ultramarine blue was added to the color. Before these clouds were dry, I worked a darker wash over them to form the dark clouds just above the horizon.

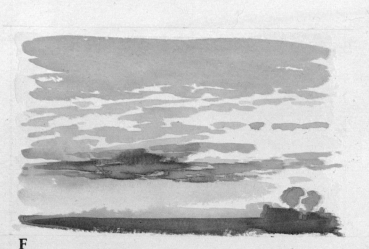

F

E

Painting A Still Life

On the following pages, I have taken nine subjects and painted them in stages for you to follow. Copy them if you wish.

I show the same painting from first stage to finished stage, explaining the work as I proceed. This is important because you see the *same painting* through all its stages. You can look back to see what was done earlier.

It is important for you to know the size of the finished painting—not the reproduction. This gives you a relative scale for analyzing the paintings. The actual size is labeled under the finished stage.

The *close-up* illustrations for each exercise are reproduced approximately the *same size* as I painted them. This allows you to see the actual brushstrokes and details. These close-ups illustrate the method of painting passages that I think you need to see more closely.

I have purposely chosen a still life for your first exercise. Objects are easy to find. They can be painted under your own conditions. This is the beauty of still life. You can control lighting, size, shape and color of your subject.

If you use inorganic objects, you can paint the same ones for years. To keep you from spending that much time on your still life, I have chosen fruit.

Here are some important notes on still-life painting. Don't be *too ambitious* to start with. Set up a few objects that have simple shapes and colors. Put them on a contrasting background.

The best light source is an adjustable desk lamp. It can be directed at your subject to give maximum light and shade—light against dark.

First Stage—Draw the still life with an HB pencil. Use your large brush. Mix Hooker's green No. 1, alizarin crimson and ultramarine blue. Paint a wash down the paper, working around the fruit. Paint over the left side of the glass jar. Paint a wash down the right side of the picture with ultramarine blue, alizarin crimson and yellow ochre. Paint over the remaining white in the jar again. Leave some white paper for highlights, as shown at right. Paint the table top with the same color.

Second Stage—Paint the raisins in the jar, using alizarin crimson, ultramarine blue and cadmium yellow pale. While the paint is still wet, dry your brush and wipe out the two highlights on the jar. Then start painting the fruit. Load your brush with watery paint. Start with the orange. Use cadmium yellow pale, cadmium red and a touch of ultramarine blue in the shadow area. Next, paint the apple with Hooker's green No. 1 and cadmium yellow pale. Add the red lines of the apple while the paint is still wet so they will blend with the green and look softer. Paint the two pears with a wash of cadmium yellow pale and Hooker's green No. 1. When they are nearly dry, paint the darker, brownish green areas with Hooker's green No. 1, alizarin crimson and yellow ochre. The onion is next. Use cadmium yellow pale and alizarin crimson. With a wash of yellow ochre and burnt umber, paint all the nuts inside and outside the bowl, except for the kernel *inside* the broken walnut. When these are dry, add alizarin crimson to your wash to give more color value to the chestnuts. Dry out the highlights with your brush. Paint the blue dish, using ultramarine blue and a little Hooker's green No. 1. Add more pigment to the wash so it gets darker to the right of the bowl. Leave a white rim on the bowl.

Third Stage—At this stage, all areas have a wash over them except highlights. But no detail or depth is apparent. Darker washes are now applied to the painting. Start with the green background, using the same colors but adding more pigment. Paint over the jar again, but *leave some areas of the original wash* showing. As you work on the fruit, use a little more brushwork to achieve form and shape.

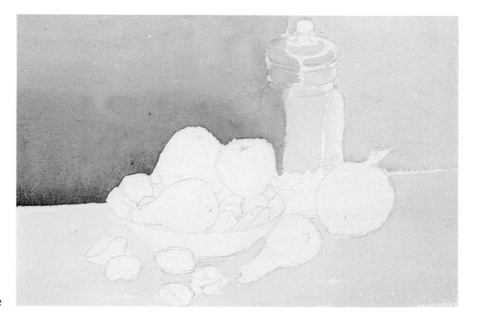

First stage

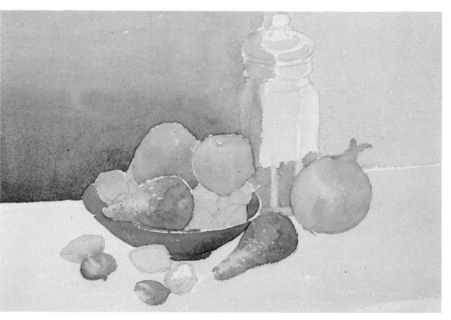

Second stage

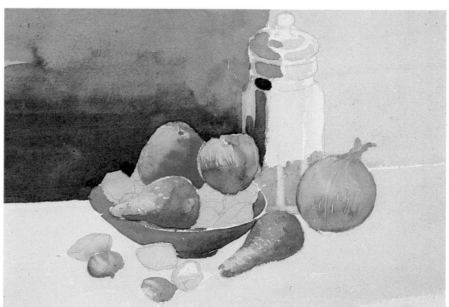

Third stage

35

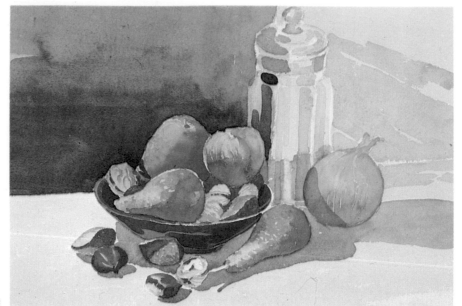

Fourth stage

Fourth Stage—Now your work on the nuts begins in earnest. Using your No. 6 brush, start with the walnuts. Use the brush like a pencil to draw the gnarled shells. If you find lines too harsh or strong, dry your brush and soften lines with it. Keep the highlights on the nuts—they are an essential feature. Now paint shadows with a wash of alizarin crimson, ultramarine blue and yellow ochre. When these are dry, add another wash to the bowl. Finally, use one stroke to put a wash down the right side of the jar and over the raisins.

Final Stage—The picture now requires sharpness and detail. This work is done with a No. 6 brush. Start with the jar. Add dark lines to give it better definition. Wipe some color off the left side of the apple to accentuate its shape and to make it contrast with the orange. Then add the stem. Paint some thin lines on the onion. Give the raisins more detail in the jar. Give all the nuts stronger colors. Paint shadows cast from the apple and pear on the nuts in the bowl. Put some stippling—small, dotlike brush-strokes—on the orange with your No. 6 brush. This helps portray the skin. Use darker paint and work from the dark area into the light. Leave light areas showing through, as illustrated below. Finally, paint all the shadows again with a stronger wash.

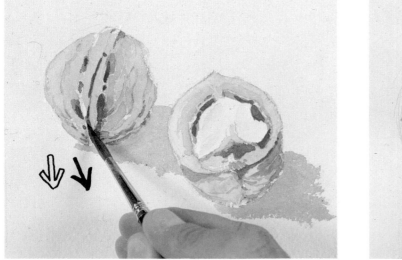

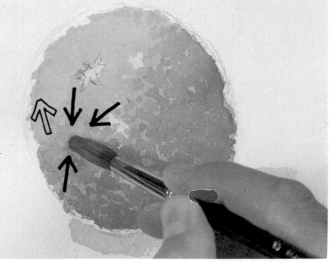

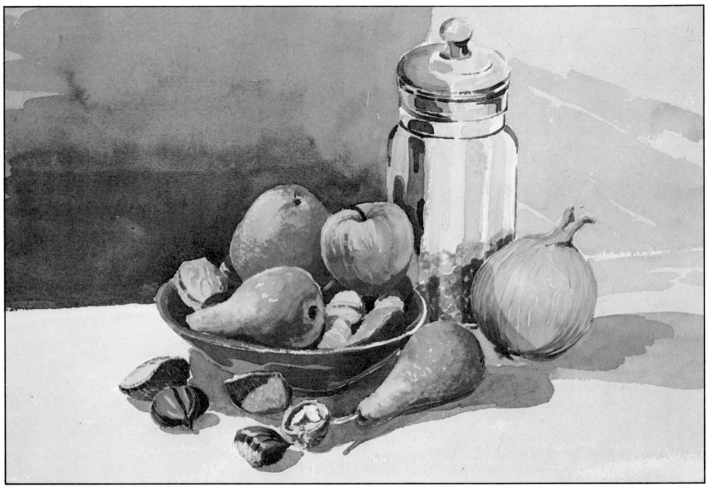

Final stage 14-1/2x10''

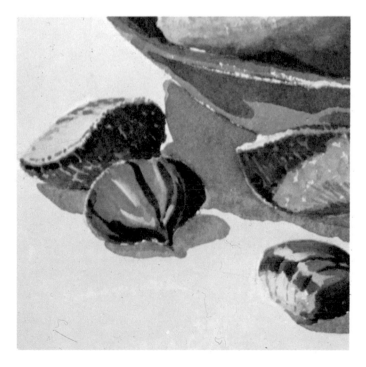

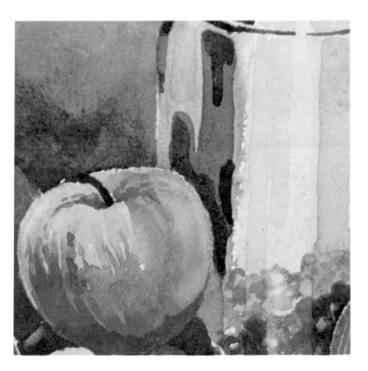

Painting Flowers

This exercise is one that you can control to a great degree. Keep in mind that flowers change over a short period and eventually die. Any flowers you use as a subject must outlive your painting time. If you don't finish in time, change the flowers for fresh ones.

Your painting skills should have progressed far enough for you to improvise. Try to express an *impression* of a flower, not a *specific* one.

A vase of different blooms with exciting shapes and colors can be an inspiration and make a fine painting. It can also be an intimidating prospect for the beginner. If this exercise is attempted before you are ready, it can lead to disaster and disappointment.

At first, study one species and only one bloom at a time. Put one flower against a plain, contrasting background so you can see it clearly. Observe its characteristics. Study how petals and leaves are shaped and how the flower grows from the stem. When you can confidently paint a single flower, put several in a vase and paint away.

You will find it helpful to use other colors in addition to those in your watercolor box. Colors of flowers are infinite. For this exercise, I have chosen flowers that can be painted with colors used in this book.

First Stage—I painted these flowers in a looser style than the still life—without extreme regard for shapes, and without worrying as much about detail. I painted the vase with deliberate brushstrokes. Brushstrokes for drawing and shadowing are the same, as illustrated below. You must be in the right frame of mind to start this painting. It is not one to be painted for days. It should be direct and unlabored. The same colors are used for flowers in all five stages. Here are the colors used: For the yellow chrysanthemum, cadmium yellow pale, not pure—add just a touch of alizarin crimson. For the red and orange flowers, alizarin crimson and a touch of cadmium yellow pale. For the shadow of the white flowers, cerulean blue and alizarin crimson. Draw the flowers and vase with an HB pencil. Next, soak the paper with your sponge and prepare plenty of watery paint in your palette. Use your large, round brush to paint the yellow flower in the center and the top yellow flower. Paint the two left ones, the shadow areas of the white flowers and the orange and red ones. Let the colors run and blend. This is intentional—start with a wet-on-wet technique.

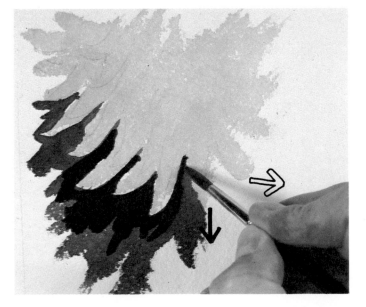

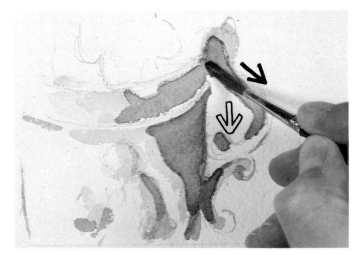

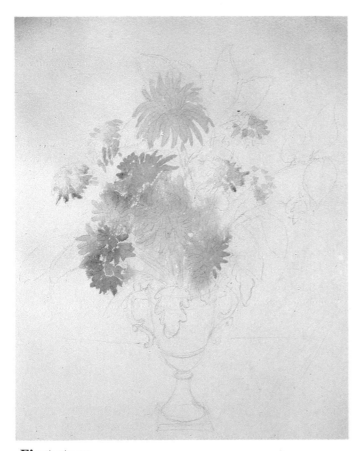

First stage

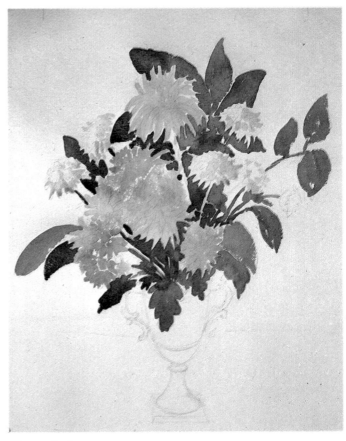

Second stage

Second Stage—Mix plenty of watery paint in your palette, using Hooker's green No. 1, Payne's gray and alizarin crimson. With your large brush, paint leaves and stems. As you draw leaves with your brush, let some of them blend into each other. Vary the values and colors of the leaves as you work. This helps give light and shade to these dark areas. Work freely into the now-dry petals of the flowers. But make sure the petals are formed in the right direction.

Third Stage—Paint the vase next, using a wet, loaded brush. Paint the handles and molding with ultramarine blue, alizarin crimson and yellow ochre. Note in the illustration how wet paint formed a natural, long puddle at the bottom of the right handle's curve. This helps portray shadows. Now add more yellow ochre to your mix and paint the background. Continue to use your large brush and work wet washes from the top downward. Go over some of the leaves. This will give them a little more depth and variation. You can now see the shapes of the white flowers on the right. Put in the shadows cast by the vase on the base. Use the same colors you used for the background.

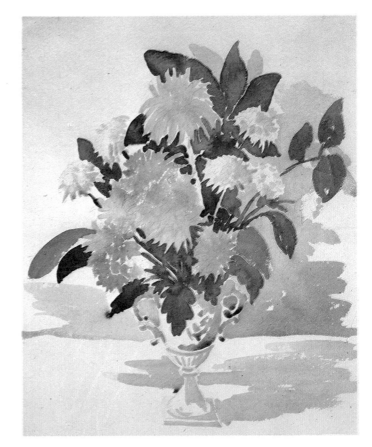

Third stage

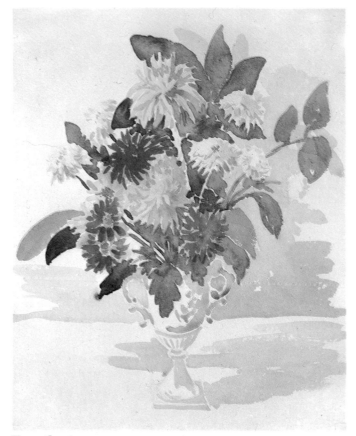

Fourth stage

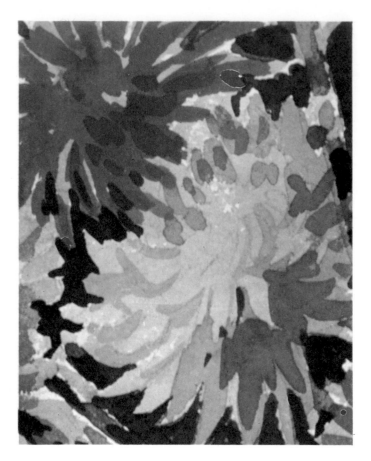

Fourth Stage—Now work over the flowers to add deeper color and form. Use the same flower colors that you started with, but use more pigment. Keep the color watery but strong in value. Use your No. 6 brush to draw the petals on the flowers. Keep the color strong, the brush wet and the brushstrokes loose. Don't worry about details. Add a little ultramarine blue where you want darker color on the red flower.

Final Stage—When using this watercolor technique, don't go too far or put in too much detail at this stage. If you do, your picture will lose its charm and freshness. Still using the wet No. 6 brush, paint over the inner leaves and main stem. Paint the dark color between petal shapes again to give the final light-against-dark accent. Notice that the two white blooms at top right appear to be *whiter*. This is a typical example of the light-against-dark principle. The leaf overhanging the vase is more pronounced now that it has been painted again. Add some more dark washes to the vase to give it more definition. This will help distinguish it from the background.

Some watercolor techniques can be executed well only when the artist is adept at that technique.

If you are feeling uninhibited, this type of flower exercise or the landscape—a later exercise—is appropriate to work on.

If you are feeling cozy, secure and mellow, then you will execute the detailed work in the still life or the pencil-and-wash drawing much better.

Painting comes from your mind, through your arm and hand into your brush. If you choose the right technique at the right time, you will get the best results.

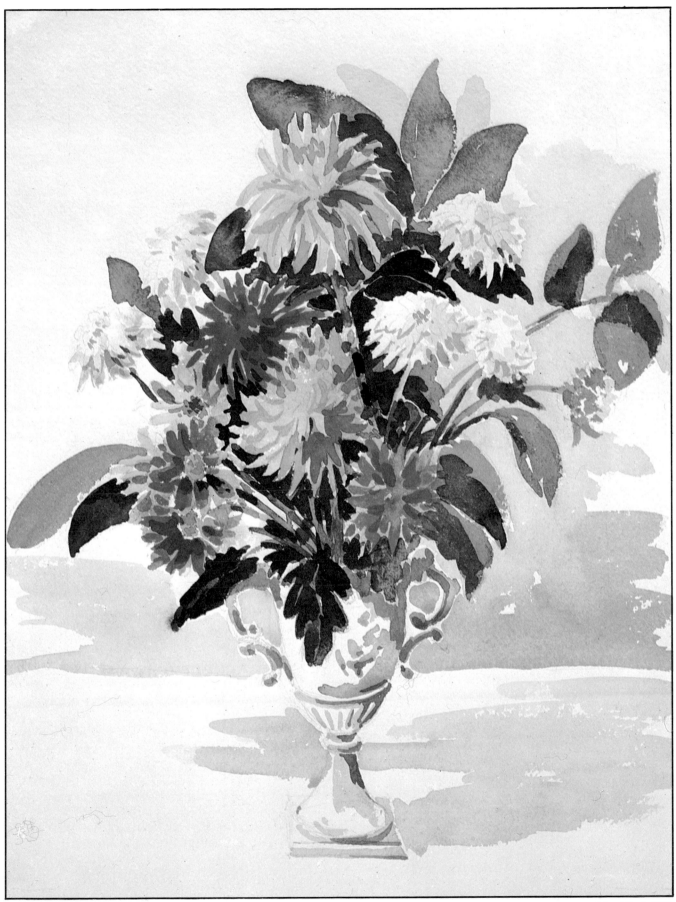

Final stage

Painting A Portrait

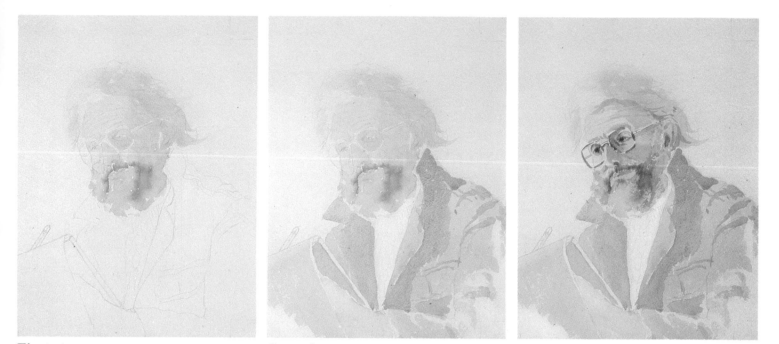

First stage **Second stage** **Third stage**

Portrait painting has many advantages in common with still-life and flower painting. You can determine lighting, color scheme and mood.

Painting a portrait does not depend on the weather—only on your model's availability. You always have one model with you—yourself. All you need is a mirror.

Watercolor is not the easiest medium to use for portraits. But it does have some natural advantages. With watercolor, you can create an impression of a subject that has a fresh and unlabored appearance. Washes can be used delicately to give depth to the skin tones.

If you start to lose quality while working on a portrait, continue with opaque watercolors or pen and ink. You may succeed in painting a good portrait. The likeness can come through as an impression—a feeling.

You can gradually build up to more detailed portraits through practice and careful observation.

First Stage—Draw the portrait with an HB pencil. Wet the paper with a sponge and wait until it is almost dry—or when the shine has gone. Use your large brush. Mix cerulean blue and alizarin crimson, and paint the hair. Leave an area unpainted above the forehead. While this is still wet, use cadmium red and yellow ochre to paint the first wash of flesh tones. Let this color mix with the hair. Use a stronger wash—add alizarin crimson and a bit of ultramarine blue to the first wash—to paint the shadow side of the face. This will mix with the wash underneath and keep the edges soft. While the face is still wet, paint the beard. Use Payne's gray and alizarin crimson.

Second Stage—Now, paint the jacket with a mix of cerulean blue and alizarin crimson. While it is still damp, add Payne's gray to your wash and put in the shadows. Paint the wrist and the shadow of the sketching pad.

Third Stage—Add more detail to the face in this stage. Use your No. 6 brush and the same colors as in the first two stages, but mix them stronger. If you get a hard line, you can soften it by stroking it with a damp brush. If it is difficult to move, wet the area with your brush and blot up the surface water with

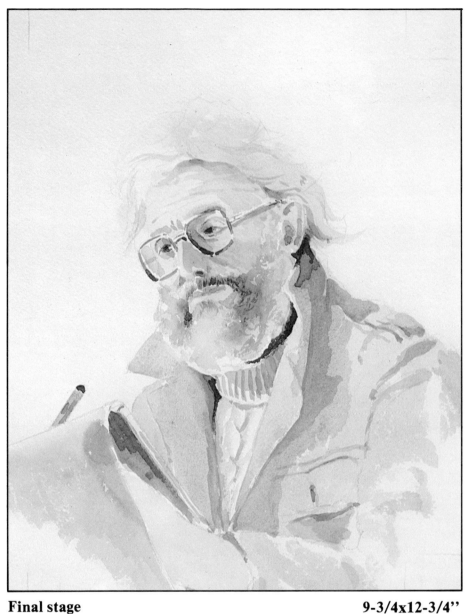

Final stage 9-3/4x12-3/4"

blotting paper. Always keep blotting paper at your side. It is invaluable for getting you out of trouble. Tissue paper works fine. When the face is dry, use ultramarine blue and alizarin crimson to paint the glasses. Leave some areas unpainted for highlights.

Final Stage—The last stage involves defining details and painting the sweater. Draw the sweater with your No. 6 brush and a mix of ultramarine blue, alizarin crimson and yellow ochre. Put dark accents under the right side of the beard, to the left of the sweater, at the back of the jacket collar and under the jacket lapel. Draw details around the jacket pocket. Put more shadow on the pad. Finally, put a small accent under the hair and paint the pencil.

Painting A Landscape

Landscape painting holds the romantic promise of an enjoyable day spent outdoors. This applies to many artists but not to all. Some worry about painting while strangers look on. Others can't get out into the country as often as they would like.

If you lack confidence, the best way to start is to find a quiet location behind a tree. In your sketchbook, make a quick drawing of a scene you would like to paint. Mark the main colors in pencil. Then paint it at home.

Take your watercolor box with you as your confidence grows.

Sketching in pencil also applies if you can't get outside often. Rather than always painting just *one* scene when you go out, make several pencil sketches. Six of them could be completed in a day. Then you can use this information to produce six different paintings at home.

A landscape can be painted from a window, if necessary. But it is good to sketch and paint outside as much as possible. Always carry a sketchbook with you. Even if you only have 10 minutes to sketch a scene and draw 10 lines, you will gain the experience of observation.

The knowledge gained by observation will be committed to your memory. Eventually you can paint indoors from memory. Take every opportunity to observe and sketch outside.

I have chosen this landscape for painting in the wet-on-wet technique. This gives the wet watercolor look. Remember to thoroughly soak your paper.

Once you start a painting like this, you are committed to continue while it is still wet.

First Stage—I get great pleasure from this watercolor technique, especially when used to the extreme, as in this exercise. It has an element of risk. Where is the paint going? It also offers great excitement. You can always plan what you want to do. You can control it to a great extent. But there is the *certainty* of many *beneficial accidents*—and even pure surprise—when using this technique. You could not copy this picture and achieve the same result. It would be impossible. You have to work toward the same composition. If a beneficial accident occurs, then use it. Your painting will have its own little gems created by the wet-on-wet technique. Draw the picture with your HB pencil. Use a minimum of drawing. Soak the paper thoroughly with water. Use your large brush and put ultramarine blue, alizarin crimson, Payne's gray and yellow ochre on your palette. *Don't* mix these colors together on the palette. Apply them to the wet paper and they will mix on the surface to create some beautiful effects. Paint the sky into the land. Notice the area left unpainted for the puddle.

Second Stage—Mix a wash of Payne's gray, alizarin crimson and yellow ochre. Paint the middle-distance trees with your large brush. These will run into sky and lose shape, but don't worry. The impression you are creating is that of a landscape in an early morning mist. While these trees are wet, paint the main trees into them. Use your No. 6 brush to add small branches. Next, place your large brush on the damp sky. Drag it down into the wet, small branch-

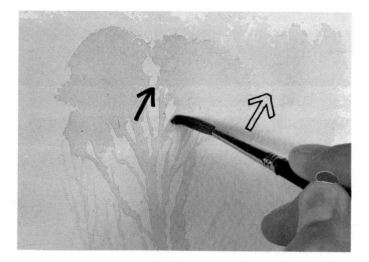

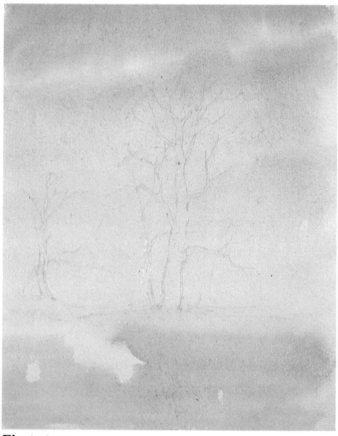

First stage

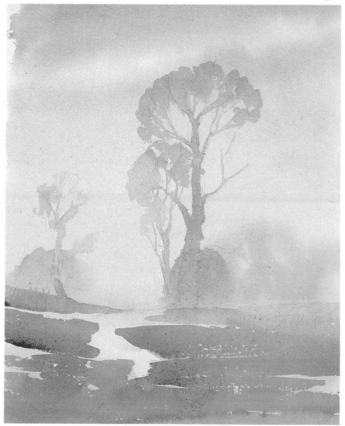

Second stage

Third stage

es—so it all runs together—to form tops of the trees. If at any stage your work dries out too quickly, wet the paper again. It may move some of the pigment. But if done gently, you can get away with it.

Third Stage—With your large brush and plenty of watery paint, paint the foreground using a mixture of Payne's gray, burnt umber, Hooker's green No. 1 and alizarin crimson. The puddle becomes more obvious when a darker value wash is added.

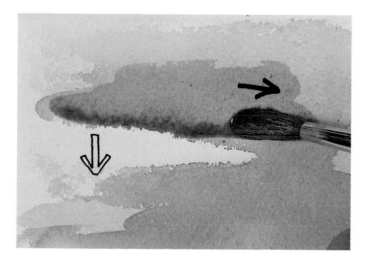

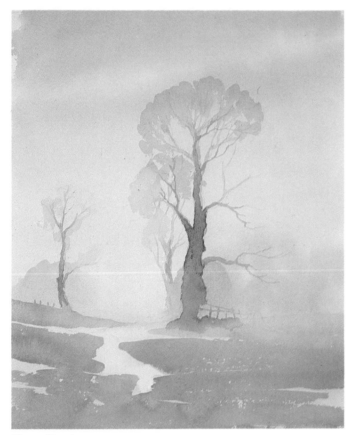

Fourth stage

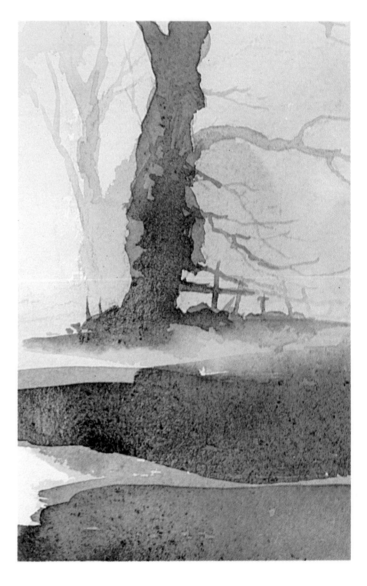

Fourth Stage—Work over the main tree again while it is still damp. Use your No. 6 brush to put in more branches. Keep them light in value at the top. Add darker value to the tree in the middle distance on the left. Add the fence to the right of the main tree.

Final Stage—Put another wash of darker color over the foreground. Add any darker accents you feel necessary for your picture. *Don't overdo the detail* when using this technique. I took about 45 minutes to complete this painting. This effect can't be achieved if you work *slowly*. The essence of the technique is *speed*. Some artists use this method to start a painting. When it has reached the finished stage, they spend a lot of time working it up into a detailed watercolor. You can try that approach next time.

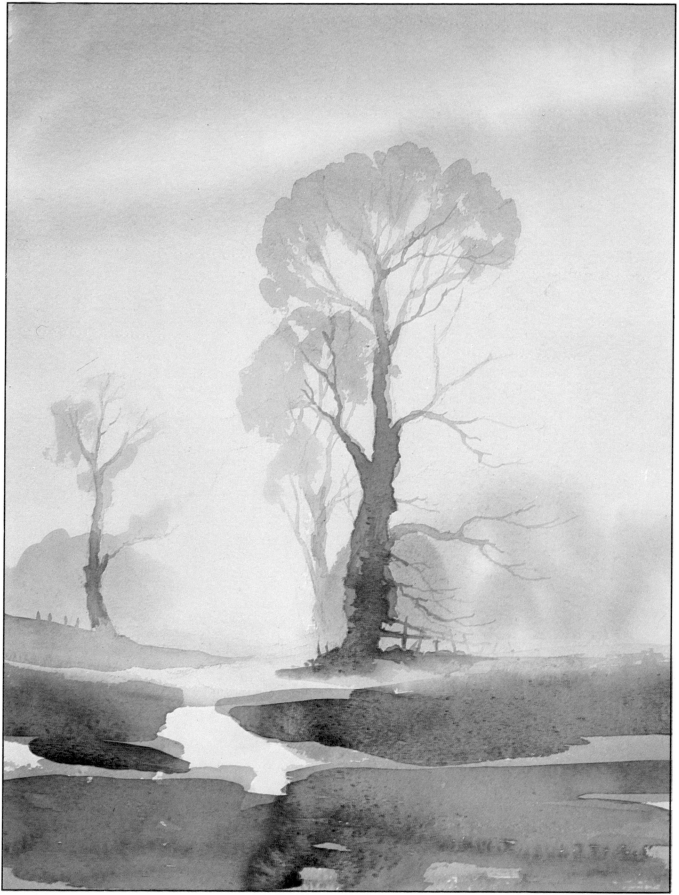

Final stage

11x14-1/2''

Painting Buildings

Buildings can be a great source of pleasure for the artist. You may be inspired by the size and splendor of a building or by the quaint, old-world charm of a village street.

Watercolor is a good medium to use for buildings. Look at buildings with a painting in mind. You will see that color areas are broken up into definite shapes. In an earlier exercise, you looked through the drinking glass to find shapes and colors. Buildings have already done this for you. Shapes of roofs, walls, windows and doors are definite. These shapes give you areas on which to work your washes. But these are controlled washes. They are different from those you used in the sky exercises.

Much of my watercolor training was done outside, sitting on the pavement. I was often near the main flow of people, painting buildings.

If you don't want to sit near a street to paint, you can usually find a corner where you can work unnoticed.

The subject of this exercise is not too complicated. I have made it a pencil-and-wash drawing. If you would rather stick to pure painting as a technique, you can do so. After drawing the main building areas, work with your washes as you did in the still-life exercise. Use the colors I suggest, but mix them much stronger.

First Stage—Draw the main area of the composition with an HB pencil. Then draw areas that you want to show through the washes. These include all areas of detail, value and shadow. When shading, it is usually best to start at the top of the drawing. Avoid working over finished, lower areas and smudging them. Start with the chimney and draw the stones. Shade only a few of them—some are darker than others. Work down to the tiled roof, then the lower part of the main building. Draw stones again as you did on the chimney.

Second Stage—Continue drawing with your HB pencil. Draw the houses at the end of the street. Note that no stonework is drawn on these. Stonework would make them appear *closer*. Then draw the house on the right. Include plenty of shading because it is in shadow. Put plenty of pencil work on the lean-to against the main building. Be careful with tiles, windows and railings in front. Draw the three human figures in broad pencil shading and the shadow cast by the man. Add dark accents with your 2B or 3B pencil. You should have a pencil drawing that could be left alone, without paint.

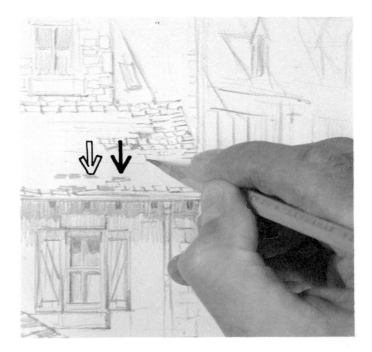

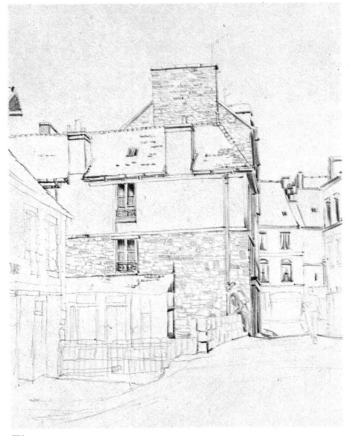

First stage

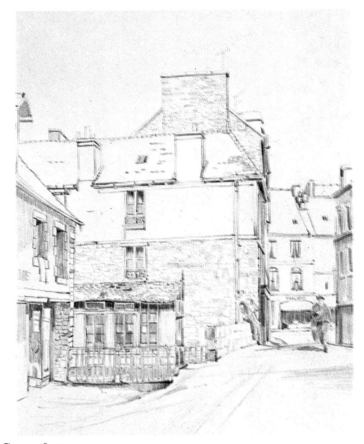

Second stage

Third Stage—I used 72-pound cold-pressed paper for this exercise. It was not stretched. I pinned it to a drawing board. A piece of heavy, white writing paper was used as a backing sheet to get a better line with the pencil. If you do not do this, the grain of the drawing board can hinder the pencil lines. Don't use excessively watery wash, because the paper is lightweight. Use your large brush to paint the sky with cerulean blue and alizarin crimson. Keep all washes *well-diluted* so they do not cover your pencil work. The pencil must show through to achieve the full beauty of this effect. Next, paint the stonework. Use raw umber, ultramarine blue and alizarin crimson.

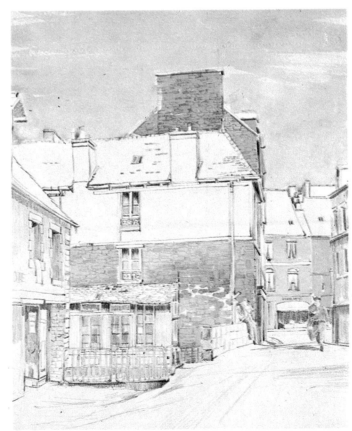

Third stage

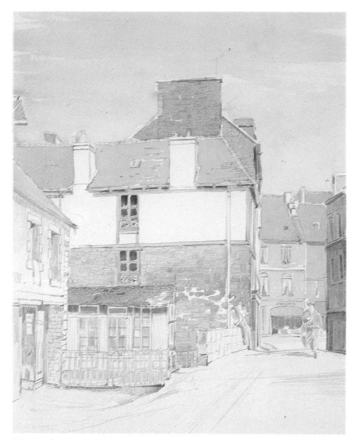

Fourth stage

Fourth Stage—Use a mixture of ultramarine blue, alizarin crimson and raw umber on the roofs. Paint the reddish tiles on the rooftops with a weak mixture of cadmium red and cadmium yellow pale. Darken this mixture and paint a wash on the windows. Put in the orange-colored wooden beams on the main house. Use the same color for window frames. Put a dark stone-colored wash over the buildings on the right. Finally, paint the reddish canopy at the end of the street with a weak wash of cadmium red.

Final Stage—Paint a wash of burnt sienna and alizarin crimson over the lean-to extension of the main building. Use ultramarine blue and alizarin crimson to paint the windows and dark area under the railings. Put a wash on the windows of the house on the left. Add a wash of yellow ochre, alizarin crimson and ultramarine blue over the front of the house on the left. Put a dark wash on the man's shape. Paint a broad, dark accent to the right of the two people standing by the main building. Apply a wash of ultramarine blue, alizarin crimson and yellow ochre to the road with your No. 6 brush. Use broad strokes. With the same brush, add any dark accents you believe necessary.

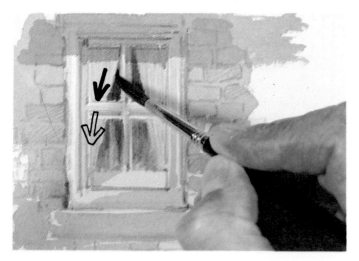

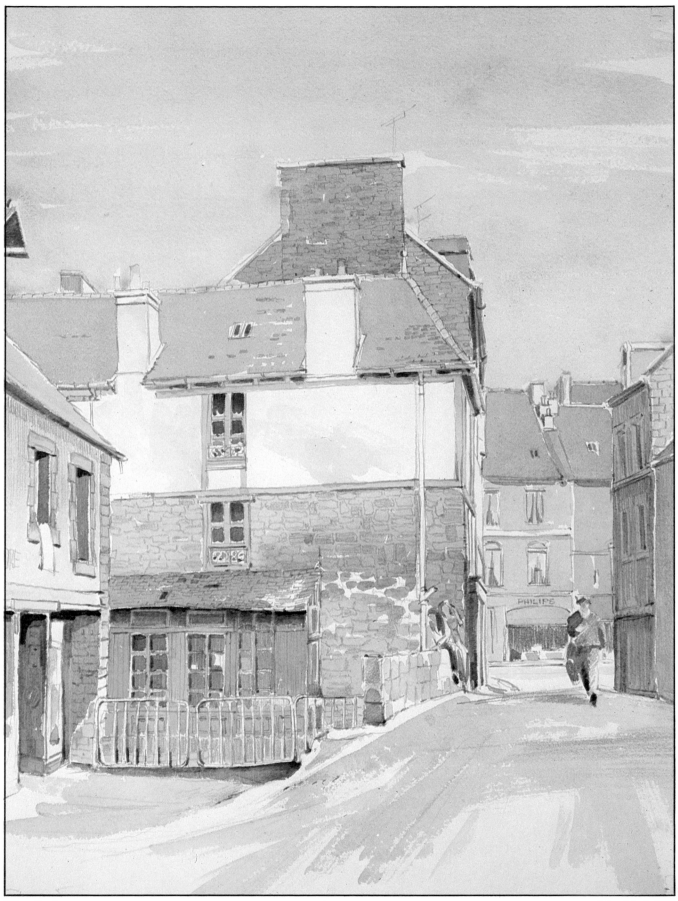

Final stage

11x14-1/2''

Painting Water

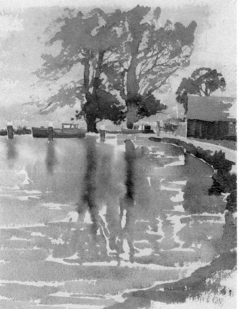

First stage

Second stage

Third stage

A lake or pond—unless muddy—reflects its immediate surroundings and the sky. In clear, still water, the reflection of a building can be mirrorlike. The reflection is painted as a building upside-down.

The reflection appears to go *down* into the water, not *across* the surface. It is only the movement of the water that shows as horizontal lines. Movement breaks up reflected images. Light on moving water is seen horizontally. The principle for painting water is to make sure that all movement lines or shapes are *horizontal*. If they are not, you will paint a *sloping* river or lake.

The illusion of water can be created easily with watercolor. Even leaving white paper to suggest water can be effective. See example D on page 33—the lake image is white paper.

Painting reflections can be approached the same way as painting glass. Observe the subject carefully. Decide what the main shapes and colors are. Then go ahead.

A wet-on-wet technique is usually descriptive of water. Learn to observe different conditions of water. Remember that a reflection immediately creates the illusion of water.

First Stage—The surroundings must be painted before you paint water. This helps determine colors and shapes on the water. Draw the picture with your HB pencil, but don't draw on the water. Shapes on the water will be created with your brush. Wet the paper with a sponge. Paint a wash of cerulean blue and alizarin crimson over the sky. Just before it is dry, put in the middle-distance trees. Use ultramarine blue, alizarin crimson and Hooker's green No. 1 on these trees. Paint the field underneath with cadmium yellow pale and a little alizarin crimson. Next, paint the boathouse roof with cadmium red, cadmium yellow pale and Hooker's green No. 1.

Second Stage—Paint the mooring posts and side of the boathouse with Payne's gray and Hooker's green No. 1. Then paint the tree trunks. Work your large brush upward with Payne's gray, Hooker's green No. 1 and burnt umber. While the trunks are still wet, paint into these with cadmium yellow pale, Hooker's green No. 1 and alizarin crimson to create leaves. Do this with your No. 6 brush. Make broad, diagonal strokes from right to left at a low angle to the paper. You will get a hit-and-miss stroke that gives the impression of leaves. Paint the boats and bank of the river.

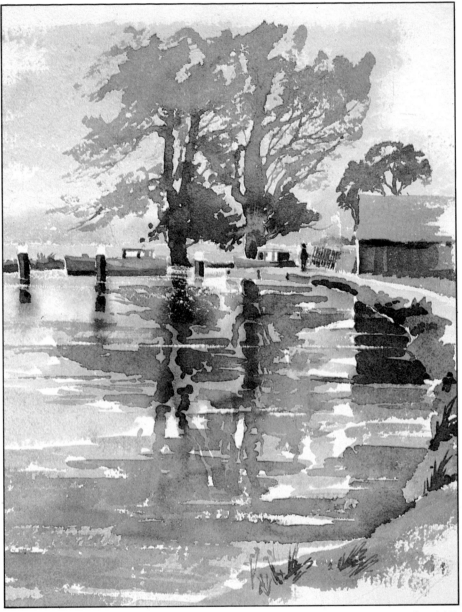

Final stage **8-1/4x11"**

Third Stage—Now wet the paper again over the water area. While it is still wet, paint in the reflected colors. Before you start, decide approximately where different shapes and colors are going to be. I often make a dry run over the paper with my brush to get the feel of where the strokes and colors will go. Look at the third-stage illustration on the opposite page. Colors merge and could be left as finished. This was only the first wash. But because colors run into each other and reflections and colors complement the background, it looks like water.

Final Stage—When the first wash is nearly dry, add more dark washes and more definitive reflection shapes. This will give greater detail to the water. Finally, scratch out some horizontal highlights with a blade.

Painting Snow

Snow has a fascination all its own. The stillness and quietness of a snowy landscape can be dramatic.

One problem of painting snow is obvious: The location is usually cold. If you are going to paint snow outdoors, prepare yourself for the weather. If you carry a sketchbook, put it in a plastic bag so it will stay dry.

When painting snow scenes with watercolor, leave as much white paper as possible to portray snow. Snow is only white in its purest just-fallen form. Even then, it reflects light and color from all around. But you need white paper on which to add colors and reflections.

Add a little blue to *cool* the snow color, or a little red or yellow to *warm* it. Never be afraid to make snow dark in shadow areas. In comparison to its surroundings, snow can be as dark as a shadow in a landscape without snow.

First Stage—Draw the picture with an HB pencil. Then wet the sky thoroughly with a sponge. While it is still wet, paint it with your large brush and plenty of watery paint. Use Payne's gray, alizarin crimson and yellow ochre. Before this wash is dry, use the same colors—but stronger—to paint the distant trees. Use broad, downward strokes. Leave the trunks of the main trees untouched.

Second Stage—Paint the three dark trees with your large, round brush. Use ultramarine blue, burnt umber and alizarin crimson. Work to the top of the tree with a wet, loaded brush. Change to your No. 6 brush and work on the small branches while the paint is still wet. While these brushstrokes are wet, dry your large brush and drag it over the small branches. This gives shape to the tops of the trees. The paint will run into the branches in some areas. This is a desirable effect. Paint the nearest tree darker.

Third Stage—Begin with the most distant trees on the left, using the same colors as before. Paint these freely with a watery brush. As you work toward the center, add cadmium yellow pale, yellow ochre and Hooker's green No. 1 to the trees that still have autumn leaves on them. Paint these with your No. 6 brush. Keep the paint watery all the time. Allow small branches to run into each other and merge. When these are nearly dry, add more distinct branches to bring these trees into focus. This will make the nearer ones appear closer. Paint the end of the hut to the right of the main tree with cadmium red and yellow ochre.

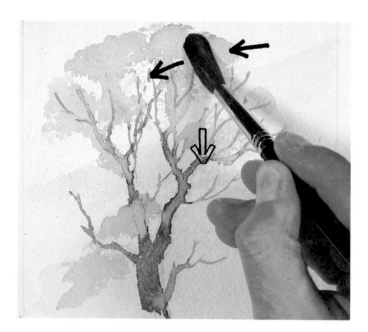

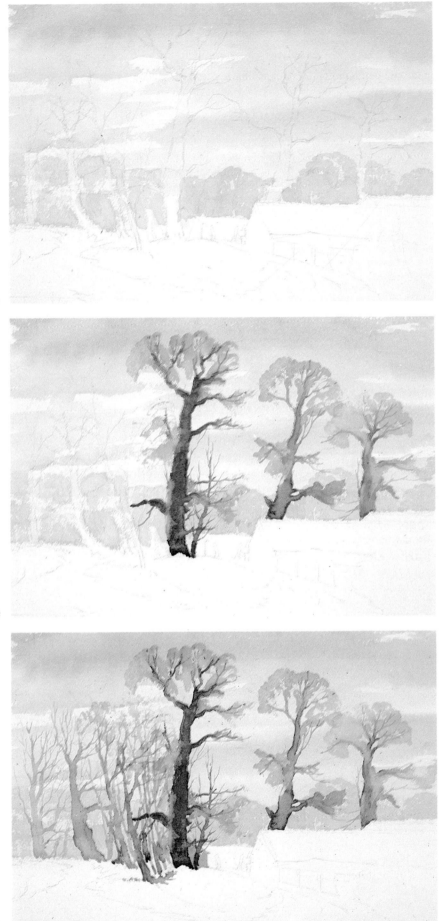

First stage

Second stage

Third stage

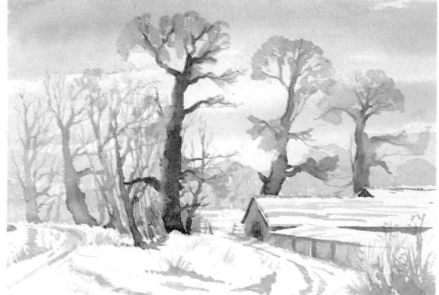

Fourth stage

Fourth Stage—Now it's time to work on the buildings. Paint the top edge of the two buildings with cadmium red mixed with cadmium yellow pale. Use your No. 6 brush. With the same colors, put in the front wall of the nearest building. Then add some ultramarine blue to your color and paint the front of the main building and the door. When this is dry, use the same color in darker values to suggest the door. Paint the shadow under the gable and the building behind, to the right. Using the same color, put in the shadow side of the main building on the right. Paint the fence at the side of the building with the same brush and color. Now put some form into the snow and path. Start by working on the ground that is not covered by snow. This is shown as ruts in the earth. Mix alizarin crimson, yellow ochre and burnt umber. Use your No. 6 brush to paint these

shapes. Keep in mind that the paper you leave unpainted will be snow. Paint the curve of the canal bank on the left. Add ultramarine blue to your color. Put reflections of the distant trees in the water at left. With a well-loaded brush, mix Hooker's green No. 1, alizarin crimson and ultramarine blue. Work upward with free brushstrokes as you paint the grass and bushes at the bottom right. Let all the colors run together. Mix ultramarine blue and alizarin crimson, and paint shadows on the snow-clad roofs of the buildings. Also paint the distant field.

Final Stage—Using your large brush, mix ultramarine blue and alizarin crimson. Paint the shadows on the snow. Continue the large tree's main shadow up the side of the building wall and over the roof. Keep your colors wet and your brushstrokes loose when you paint these shadows. Look at the paper first, decide where you want to paint them, then go ahead. If you cover up too much white paper, the look of snow will start to disappear. At best, the sun will appear to have come out. Put more detail in the large tree and the one to its left. Paint more small branches and dark accents where necessary.

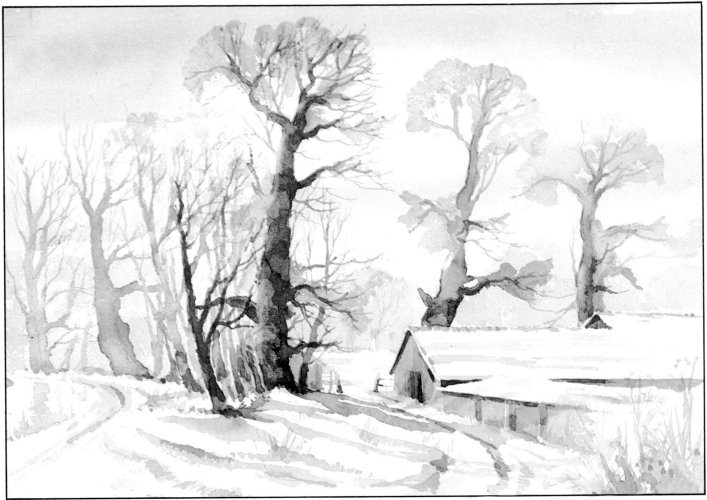

Final stage 14-1/2x10''

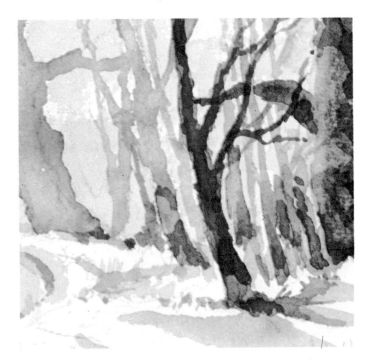

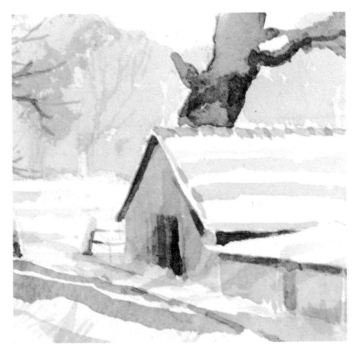

Painting A Harbor

Artists who like painting the sea usually enjoy painting harbors and boats. Similar emotions are aroused when we paint these three subjects.

But boats have one important difference: They allow us to have more control over the sea. We feel secure in the knowledge that life is around, especially in a harbor. Boats are everywhere in this painting of a British harbor. They create a feeling of activity. The sun is dancing on the boats and water.

You need more knowledge of drawing to paint boats than to paint a landscape. If you paint a branch of a tree lower than the real one, it will still look natural in your painting. But if you paint the mast of a boat at the wrong angle, the painting will look obviously wrong.

If possible, spend a few days sketching all the details of a small harbor. This might include an old wreck, sticking out of the mud like the backbone of a great fish, or an old piece of rusty and abandoned chain. You will acquire a lot of knowledge and an invaluable familiarity with boats and their surroundings.

This harbor scene was painted from a sketch. I had plenty of time to correct the drawing and make a careful study on paper in the studio. The drawing would have been less detailed if I had painted this outside. The painting would have been impressionistic.

Because of the amount of drawing in this active harbor, I decided to let you paint this as a pen-and-wash drawing.

This portrays a sunny, summer afternoon. Don't be afraid to use your colors.

First Stage—Use your HB pencil to draw the picture. Make sure the bottom edge of the harbor wall—the water level—is *horizontal*. Use your large brush to paint a wash of cerulean blue and alizarin crimson on the sky. Add more alizarin crimson and water as you near the rooftops. Paint the rooftops with your No. 6 brush and a wash of ultramarine blue and alizarin crimson. Add cadmium yellow pale to the wash and paint the buildings. Let some of the darker color serve as shadows on the buildings. Add Hooker's green No. 1 to this color and paint the trees. Add more ultramarine blue to the same wash. Paint the near side of the harbor wall. Water down the wash for the distant part.

Second Stage—Start working from the left side of the houses with your No. 6 brush. Finish the houses and small boats. Use darker values. You can suggest windows with just one brushstroke. Don't worry about extreme neatness with your washes—the pen and ink will add structure to everything. The ink lines unify the picture. Now paint the distant houses, making shapes that suggest buildings. Work on the middle-distance boats with the colors shown. Where you have a white boat, use ultramarine blue and alizarin crimson for shadow areas. Paint these boats freely. Don't get too involved in detail. This will be done by the pen. You are seeking form expressed by color, light and shade. For the woodwork on the boats, use burnt sienna and ultramarine blue. Paint from the distant boats up to the nearest ones.

Third Stage—Now you are ready to paint the water. You worked on *wet* paper when you did this in the water exercise. In this harbor scene, *don't* wet the paper first—work on *dry* paper. Use your large brush. Mix a wash of cerulean blue and a little alizarin crimson to reflect the sky color. Be ready with the colors of the boats. Now, start at the harbor wall and work downward in the painting. It is important in this technique to *leave plenty of white paper showing*. Use the brush in a free manner in horizontal strokes. Add boat-colored reflections as you come to them. If the paint runs into another part of the water, allow it to happen. This helps create a realistic, watery look. Now, paint the flat stones on the edge of the harbor wall with ultramarine blue, alizarin crimson and yellow ochre. Use your large brush. Keep the strokes horizontal.

Fourth Stage—Now you are ready for pen-and-ink work. This can be done with several types of pens, using various methods. You can use a felt-tip pen with a fine point, a fountain pen or a dip pen with a fine nib. The advantage of using a dip pen is that you can draw *extremely fine lines*. You can't do that with other pens. If you use a felt-tip pen, you can make the stroke *downward or upward* equally well. If you try this with a dip pen and use too much pressure or the paper has too much tooth, it will scratch the paper on the upward stroke. Your work will be splattered with ink. The down stroke can be heavy in pressure, but the up stroke must be lighter. Prac-

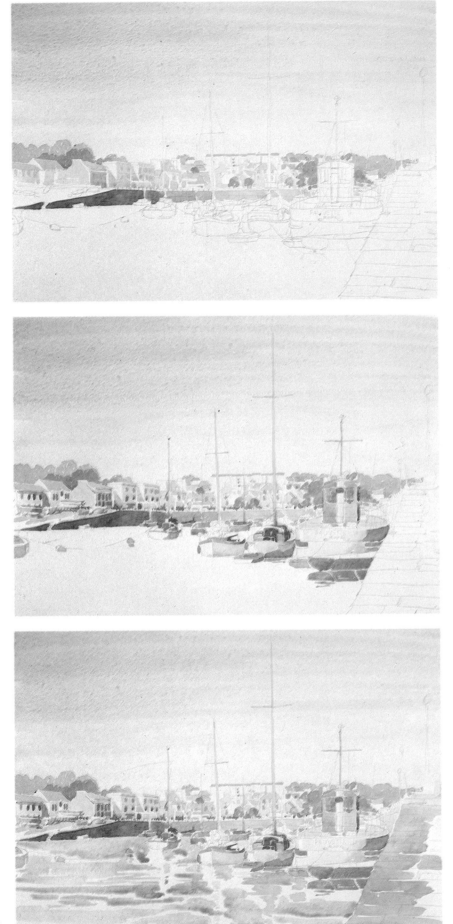

First stage

Second stage

Third stage

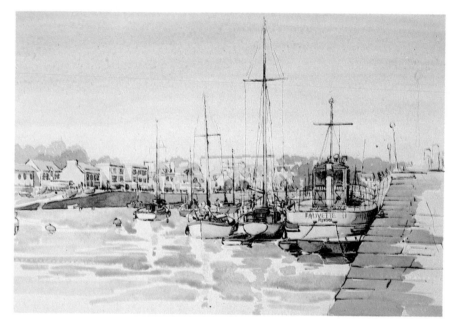

Fourth stage

tice on paper before trying it on a painting. Become accustomed to your pens. Use black, waterproof India ink. Start on the left of your picture. Draw houses, windows, shutters, shadows under the eaves and so on. Work into the distant houses. Then use your pen lightly to get *thinner* lines—these houses have to appear to be on the *other side* of the harbor. Now, work on the most distant boats in the harbor to give them shape. Doodle a little with the pen here and there to give a complicated, crowded look in the middle distance. Work forward toward the nearest boats. Put in more detail as you near the wall at right. Draw the masts and rigging of larger

boats. Suggest stonework on the harbor wall to the right. Your pen lines can now be stronger.

Final Stage—The water is the last stage. Use your pen at a lower angle than you did for the boats and general work. See the lower right illustration. The pen is held very low and makes horizontal strokes. These become thicker and more varied than other pen work. Continue to leave plenty of white paper. Add other accents or harbor details with the pen. If you prefer—I didn't here—add more color or darker values with paint.

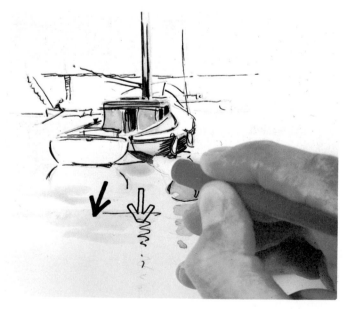

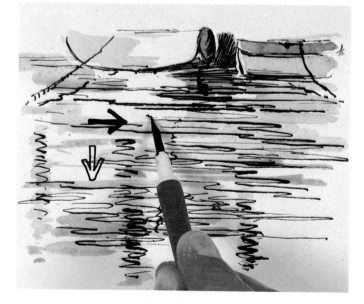

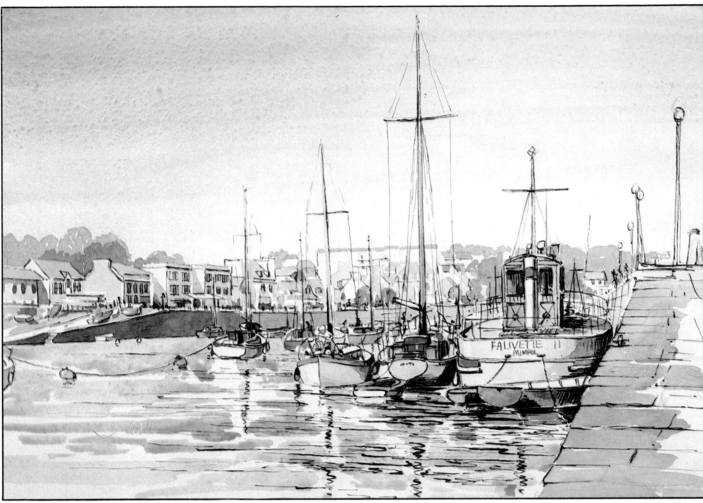

Final stage **14-1/2x10''**

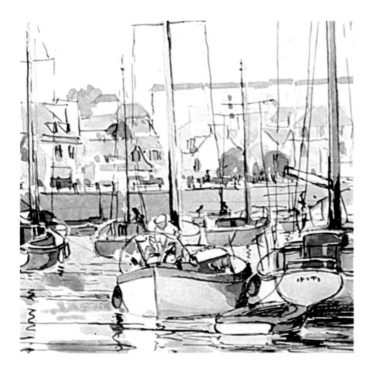

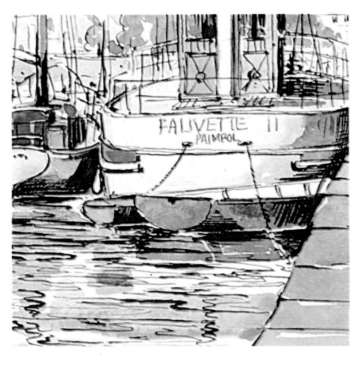

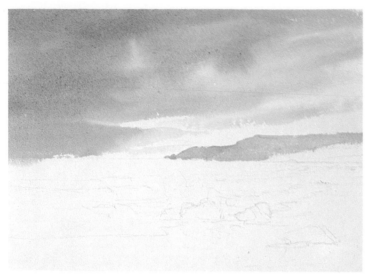

First stage

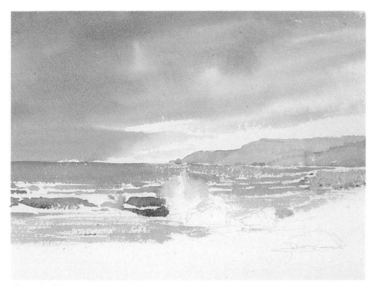

Second stage

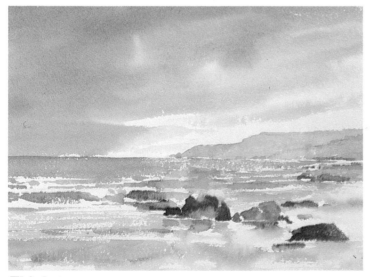

Third stage

Painting A Seascape

The sea has always fascinated artists with its extremes of mood. It can be romantic—or terrifying.

The sea changes color and is always moving, like the sky. This must be observed from life.

Sit on the beach and watch wave after wave coming in to learn how each is formed and how it breaks. Then try sketching with a 3B pencil. Concentrate on the overall form of the wave. You can't draw the same wave but there's an endless supply of them. You have to preserve an image to carry on to the next wave.

The horizon line must always be *horizontal*. Otherwise the sea will appear to be falling off the paper. If necessary, draw it with a ruler.

The sky must match the sea in color and value. You usually paint with the same colors for both.

To give a seascape more interest, include cliffs, beaches, rocks and boats. Cliffs and points of land give distance and perspective. Beaches and rocks provide the opportunity to paint crashing waves and flying spray.

First Stage—I took this painting to the third stage as a pure watercolor. In the final stage, I finished it in opaque watercolor. I did this to demonstrate how you can add white to your colors and save a painting that is failing in quality. This is another method of producing an opaque watercolor painting. Start with watercolor washes. When the painting is established, add white and continue in opaque paints. My other opaque watercolor painting on page 26 was not done this way. I added white to the colors at the start. Now, wet your sky area thoroughly with water—*but not by the point of land*. Paint the sky with your large brush. Use Payne's gray, ultramarine blue, alizarin crimson and yellow ochre. Use the same colors with a touch of cadmium yellow pale to paint the far land mass.

Second Stage—Paint the sea with Payne's gray, ultramarine blue, Hooker's green No. 1 and alizarin crimson. Leave white areas where the waves are breaking. Use drybrush to get a sparkle on the water.

Third Stage—Paint the rocks with burnt umber, ultramarine blue and Hooker's green No. 1. Then use your large brush to wet the beach and paint it in broad strokes. Use the same colors as for the sea but add yellow ochre. The paint will run to give lovely, soft, watery effects.

Points To Remember

- Observation is the key to good painting.
- Plan your watercolor before you start.
- Keep brush fully loaded with watery paint when working on a wash.
- Wait for one wash to dry before applying another—unless you are painting wet-on-wet technique.
- Use white paint only in the opaque watercolor technique.
- Clean white paint off your palette when finished.
- Stretch thin paper to avoid buckling.
- With watercolor, work from light to dark.
- Use the best-quality sable brushes you can afford.

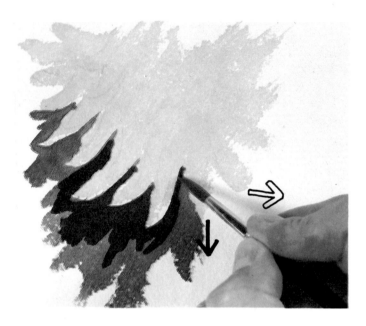

- Always keep colors in the same positions in your watercolor box.
- Keep practicing to achieve success.

6.4298357982

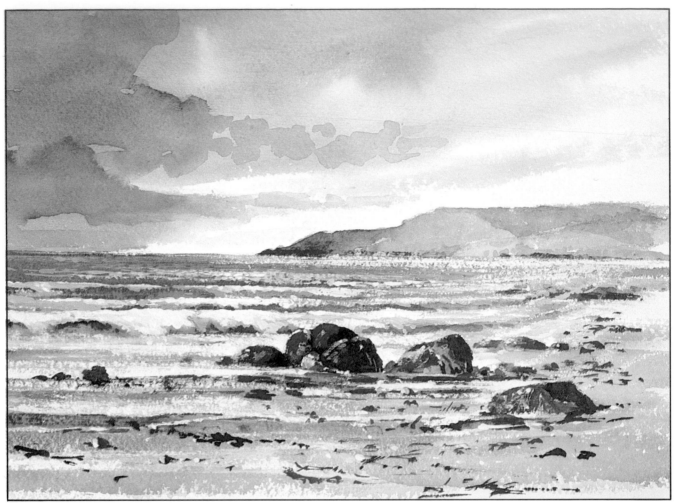

Final stage　　　　　　　　　　　　　　　　　　　**13-3/8x10"**

Final Stage—Put another dark wash over the sky and sea before you add white to your colors. For the middle-distance sea, use white with ultramarine blue and your No. 6 brush. Paint the waves—see center illustration at right. Put the shadow cast by the heavy clouds on the land mass. Use almost pure white—add just a little alizarin crimson and cadmium yellow pale—to form the large waves. Darken them underneath for shape and form. Darken the beach with stronger colors. Use drybrush technique to add white in horizontal strokes for the foam rolling up to the rocks. Now, add more rocks in the distance. Draw some flotsam on the beach. Add some white lines on the beach to create ripples of water and some lighter values on the rocks to show sunlight. White is added to *all* the colors in this stage. This is a very popular technique. But you have to practice to get good results.

Now that the last exercise is finished, you should be capable of handling watercolors effectively. Don't worry about a painting that goes astray. You will find this happening occasionally with watercolors even when you are experienced.

Keep painting and good luck.

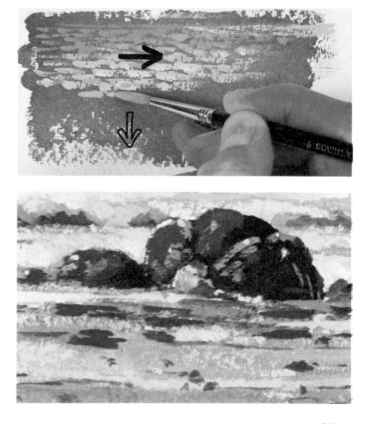